Interpretive Master Planning

Interpretive Master Planning

Volume Two: Selected Essays

Philosophy, Theory and Practice

John A Veverka

MUSEUMSETC | EDINBURGH

Contents

PHILOSOPHY

A note to readers: This book has been designed so that it can either be read from cover to cover or, alternatively, easily be consulted for help with a specific issue or dilemma. So that chapters can be studied individually and still provide cogent guidance, similar recommendations will, where relevant, be found in more than one chapter.

PHILOSOPHY

1

Interpretive Philosophy and Principles: An Overview

Many people have heard the word interpretation. Yet, this word may have a wide range of meanings for people based on their background, training, or experience in the interpretive profession. However, I feel that the best definition of interpretation is the one developed by a task force of Interpretation Canada which set out to develop the definition that would be used within Canada (1976). That definition has been picked up over the past 17 years by many other organizations, and is the one most often taught in university courses in interpretation. This definition is:

Interpretation is a communication process, designed to reveal meanings and relationships of our cultural and natural heritage, to the public, through first hand involvement with objects, artifacts, landscapes and sites. - Interpretation Canada

It should be stressed that interpretive communications is not simply presenting information, but a specific communication strategy that is used to translate that information for people, from the technical language of the expert, to the everyday language of the visitor.

Where do the basic strategies, techniques and principles of interpretive communications come from?

It is important to remember that the communication process of interpretation did not spontaneously appear one day. Interpretation (the profession, and the techniques and approaches) are a wonderful mix from communication principles from many other professions including:

- Journalism

- Marketing
- Psychology
- Non-formal and adult education theory and presentations.
- Business management and finances.
- Recreation and tourism planning/principles
- Media planning/design principles.

In reality, we see the use of interpretive techniques and principles every time we see an advertisement in a magazine or on television.

Understanding the audience

One of the key areas of knowledge that interpreters must have to be effective in their presentations is an understanding of how visitors learn and remember information in a recreational learning environment. A recreational learning experience is one where the person has self-selected to attend or participate in a program for fun. The learning that occurs is viewed as fun as well. Anyone that has a hobby, such as coin collecting, model making, studying aspects of history, bird watching, etc. is involved with recreational learning. We learn because we want to, and the process of learning and discovery gives us pleasure.

Information, environmental education and interpretation: what's the difference?

I am often asked what, if any, are the differences between the three: information, environmental education, and

interpretation.

Information presented to visitors is just that, straight facts, figures and dates. A field guide to birds provides information about the bird species, but usually no interpretation. But all interpretation contains information. Interpretation is not what you say to visitors, but rather the way you say it to them.

Environmental education (either the formal education process, or the hopeful result of a program or exhibit), can be presented in either a informational or instructional approach or using an interpretive approach. Remember, interpretation is a communication process. If the process works in presenting and translating the information about the environment in a way that is meaningful for the audience, then environmental education occurs. I believe that true education occurs if the recipient of the communication: 1) receives the message, 2) understands the message, 3) will actually remember the message and 4) possibly USE the information in some way. I have seen many formal environmental education programs where very little education occurred. Participants were presented information, remembered parts of the information, but probably really didn't understand the answers that they were giving back to their teachers. I have also seen teachers in formal classroom environmental education programs use interpretive techniques that left their students inspired, motivated, and excited about learning more.

Interpretation is not topic- or resource-specific. The interpretive communication process can be used for interpreting anything, any subject. If the interpretive

communication is effective, then education can occur about that subject. Interpretation is an objective-driven, and market (audience) focused process that looks for results (the accomplishment of stated objectives). It uses marketing and advertising techniques, journalism strategies, and a host of other communication strategies to form our Interpretive Communications Strategy. Interpretation is also fun – a recreational learning experience. What is the Interpretive Communication Process?

The communication process used to interpret information is based on Tilden's *Interpretive Principles* (Tilden, 1954). Tilden's basic communication principles are also the ones you will find in every first year marketing or advertising text book on successful communication with your market (audience).

First, the communication must *provoke curiosity, attention and interest* in the audience. If you can't get their attention, they won't even stop at an exhibit, want to attend a program, or pay attention during programs. In planning the strategy as to how to provoke attention, the interpreter has to consider the answer to the question: Why would a visitor want to know this information? The answer to that questions ends up being the graphic, photo, or statement that gets the audiences attention.

Continuing with the answer to the question *why would a visitor want to know this?* the interpretation communication must find a way to *relate the message to the everyday life of the visitors.* In advertising, it's the answer to the question: why do you need this product or service? This part of the communication gives people reasons to continue with the

exhibits, programs, or media – gives them a reason to pay attention and want to learn more.

The final part of the process is *revelation*. Tilden says that we should *reveal the ending or answer of the communication through a unique or unusual perspective of viewpoint.* Save the answer to last. The reveal tells the visitor why the message was important for them, or how they can benefit from the information that was interpreted to them.

Strive for message unity is another principle for interpretation. It means that when we plan or design our program, service, or media, that we use the right colors, costumes, music, designs, etc. to support the presentation of the message. Think of message unity as the stage setting and props for a theatrical presentation.

Address the whole. This final principles means that all interpretation should address some main point or theme – the big picture of what is important about the park, historic site, tourism site, etc. that the visitor is at. The main theme is best illustrated by your answer to the question: if a visitor spends time going to programs, looking at exhibits, etc. while they are visiting my site, by the time they are ready to go back home if they only remember or learned one thing about why our site is so special, that one thing better be...! The answer to this question is *the whole.* An example of such a theme might be: We are using state-of-the-art wildlife restoration techniques to improve this site for people and for wildlife.

In short hand, we can summarize the basic principles of interpretation as:

- Provoke
- Relate
- Reveal
- Address the whole
- Strive for message unity.

In addition, interpreters must ask two questions to help them plan and design their interpretive program, media or service.

1. Why would the visitor want to know that? If you can's answer this question, you are going to have trouble marketing the program or service. We don't want to be in the business of giving answers to questions no one is asking.
2. How do you want the visitor to use the information you are interpreting to them? If you don't want visitors to use the information you are interpreting, then why are giving it to them?

There are not any right or wrong answers to these questions. It does help the interpreter focus on interpretive something relevant to the visitors.

The model of interpretation

There is a basic model of the total communication process (Fig. 1). In this model of interpretive communications we can see several different components. First, we must have some message (*What*) that we want to convey – what is the story that we want to tell? Then we must have specific objectives that we

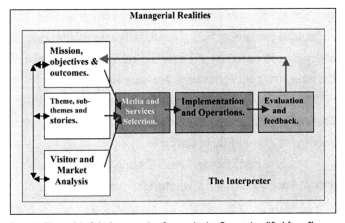

Figure 1: The model of the Interpretation Communication Process (modified from Cherem, 1976).

want the message, program or service to accomplish. We have interpretive techniques that we can use to actually present the message (Tilden's principles), and services in which to use the techniques (self-guiding trail or auto tour, live program, exhibits, publications, etc.) We are communicating our message to visitors, so we need to know as much as possible about them (visitor analysis). We will only know if our message as received and understood by the visitor if we evaluate the program or service to see if our original objectives were accomplished. If not, we need to go back to make some adjustments. Note the Implementation and Operations box, which includes considerations, such as costs, staffing or material needs to actually plan, design or build the interpretive programs or services (such as exhibits).

The box that surrounds the model called Interpreter is each individual program presenter or planner. We each bring our

own unique perspective to any project or program. We have our unique personalty, background, and presentation style. So each program or service will have the individual fingerprint of the interpreter who planner or presented it.

The big box around everything is managerial realities. These are administrative issues that can/do influence programs or services. Some of these can include:

- Agency policies and goals for interpretation.
- Program or services demands from the public.
- Management issues that interpretation needs to help with.
- Available budget for programs or services.
- Time constraints and project deadlines.
- Political pressures for certain programs or services.
- And more... what are yours?

Summary

This chapter has focused on a discussion of just what is interpretation. Interpretive Communication principles have evolved from a variety of other communication professions. The basic principles of what makes a presentation interpretive vs informational is not so much on what you say, but rather how you say it.

For the communication to be interpretive, it must Provoke, Relate, Reveal, Have Message Unity, and Address the Whole. The model of interpretation shows how the total communication process works, and becomes the basis for developing a philosophy and strategy for Interpretive Planning.

References

Lewis, William 1980. *Interpreting For Park Visitors*. Eastern Acorn Press.

Tilden, Freeman. 1957. *Interpreting Our Heritage*, The University of North Carolina Press, Chapel Hill.

2

Exactly What Is Interpretation?

It is pretty well accepted that parks and museums need interpretation. Many parks need to have, or have had developed for them, an Interpretive Plan. And there are classes and workshops on developing interpretive media as well. But what does *interpretive* actually mean? It is a word used quite freely, but probably without a clear definition of what it actually means. It's sort of like the word *ecology*. You know the word, can you accurately describe what it means? Quite often *interpretation* or *interpretive* is simply another word for putting lots of information, photos, and text on panels. So for those folks involved in developing interpretive plans and media in the future, I thought this short overview of what interpretive actually meant might be useful.

The first book on interpretation was written by Freeman Tilden in 1957 – *Interpreting Our Heritage*, where he set out the six basic principles of Interpretation.

1. Any interpretation that does not somehow *relate* what is being displayed or described to something within the personality or experience of the visitor will be sterile.

2. Information, as such, is not interpretation. Interpretation is *revelation* based upon information. They are entirely different things. However all interpretation includes information.

3. Interpretation is an art, which combines many arts, whether the materials presented are scientific, historical or architectural. Any art is in some degree teachable.

4. The chief aim of interpretation is not instruction but *provocation*.

5. Interpretation should aim to present a whole rather than a part, and must address itself to the whole person rather than any phase.

6. Interpretation addressed to children should not be a dilution of the presentation to adults, but should follow a fundamentally different approach. To be at its best it will require a separate program.

From these basic principles we have developed a shorthand version I call *Tilden's Tips*. Good interpretation must:

· Provoke the interest of the audience.

· Relate to the everyday lives of the audience.

· Reveal the main point through a unique ending or viewpoint.

· Address the whole (focus on illustrating a theme).

· Strive for message unity (use the right illustrations, vocabulary, etc. to present the message).

From these basic principles some definitions of interpretation have been developed. The one I like best and think is the most accurate was developed by *Interpretation Canada* in 1976. That definition of interpretation is:

Interpretation is a communication process, designed to reveal meanings and relationships of our natural and cultural heritage, to the public, through first hand experiences with objects, artifacts, landscapes, or sites.

Another way I like to think of it is:

translation from the language of the expert into the conceptual language of everyday people (non-experts).

I think that the key element here is that *interpretation is a communication process*, one that Provokes, Relates, and Reveals the message or story to visitors using a variety of media. Thus an *interpretive panel* is not interpretive because of contains information, it is *only* interpretive if the communication process used in its design, copy development and presentation actually follows Tilden's Principles.

On the next page is a sample of label copy using an *interpretive communication* approach. This was developed for a self-guiding historic walking tour booklet. It is stop #4 on the tour.

This approach can be used for interpreting any subject matter, but the main point here was to illustrate the use of interpretation in creating the copy. Can you identify the Provoke, Relate, and Reveal used in developing the copy?

You see interpretation used every day!

You probably didn't know this, but Tilden's principles of interpretation are the same principles used in marketing and advertising – that's where I think Freeman got them from in the first place. He was a journalist and saw these strategies being used in creating headlines and provocative writing, as well as in creating advertisements. For example, all of the super bowl commercials used Provoke, Relate, Reveal – as

 4

The Jackson Club's dark secret!

In 1842, this was the location of the Jackson Club, a club, for Men Only! This was the place where the elite of Jackson came to do business, visit, and talk about the news of the time. And becoming a member was not easy – you had to be somebody important!

Mike Sommerville was somebody! Arriving in Jackson in 1843, he quickly developed a reputation as a powerful businessman, and was invited to become a member of the Jackson Club. Mike served two terms as club president, and even helped increase the membership of this Men's Only organization. A proud member for 25 years, it wasn't until Mike's death in 1869 that it was discovered – that Mike was really… Michelle – Yep! A Woman!

Your next stop on the tour is just one block down this street on the right, a large white home, number 321. It looks like an ordinary home, but there's an extraordinary story buried in the garden. I'll meet you there with a shovel.

well as most other TV commercials. Look at any ad in any magazine – you will see Provoke, Relate, and Reveal used in the design and copy for that piece.

Is your interpretive media "interpretive"?

If you want to check your work and see if your interpretive media is actually interpretive, not just full of "answers to questions no one is asking", look at your panels, exhibits or publications and ask:

- Where is the use of *Provocation* – are there provocative headers or provocative graphics that will get grab viewers attention and spark their curiosity?
- Where is the use of *Relate* in using analogies, metaphors, and "examples" that will relate to the everyday life of the viewers and help them understand the concepts?
- Does the interpretation *Reveal* the main point – does the copy and presentation hold the visitor and gets them to want to find the answer or key point to the interpretation? Is there an "Oh – now I understand!" at the end of the interpretive communication?
- Did the interpretive panel or media relate this individual stop or site to the larger total byway theme, or was this just information on a stick?

In developing your interpretive media, interpretation communication asks two main questions for you to consider as you develop the content each panel, exhibit or tour:

1. *Why would a visitor want to know this (information)?* If you

can't answer this question, then you have a problem. If you can answer the question – you have the beginnings of your *Provoke*, and *Relate* components.

2. *How do you want the visitors to USE the information on the interpretive panels or from the interpretive media?* Because of they can't use the information – then why are you giving it to them? Why would then want to remember it?

How you answer these two questions will help direct how you might use Tilden's Principles in developing real interpretation. There is not a "right" answer here – but this helps in the interpretive planning process for content and graphics selection.

Summary

Interpretation is not something that magically happens no matter what you put on panels, tour booklets or other media. Outdoor panels are not instantly interpretive panels – in fact most "interpretive" panels out on sites today are *not interpretive – just informational*. Real interpretation requires that Tilden's Principles of interpretive communication be used to create the message that is developed for the media in question. To be interpretive the communication must:

- Provoke the interest in the audience;
- Relate to their everyday lives in some way;
- Reveal the main point of the interpretation in a creative, unique or memorable fashion;
- Address the whole interpretive theme for the total site;
- Strive for message unity – using the correct graphics,

colors, etc. that support the total byway interpretive theme.

And finally, good interpretation always leaves the visitor asking for more!

References

Tilden, Freeman. 1957. *Interpreting Our Heritage*. The University of North Carolina Press, Chapel Hill.

3

Creating Interpretive Themes

What is an interpretive theme?

A theme is the central or key idea of any presentation. When communication to your visitors has been completed (via exhibits in a visitor center, self-guiding tours, live programs, or other means), the audience should be able to summarize the main point of the communication in one sentence. This sentence would be the theme. Development of a theme provides organizational structure and clarity of understanding to the main message of the site or facility. Once the main interpretive or story message theme has been decided, everything in presenting the programs or services to the public falls into place.

Themes should:

- Be stated as a short, simple, complete sentence.
- Contain only one main idea if possible.
- Reveal the overall purpose of the site, facility, agency, program, visitor center, etc.
- Be specific.
- Be interestingly and motivationally worded when possible.

Thus: *History of the area* is *not* a theme – it is a topic. I have to ask "what about the history of the area?" A theme would be: *The history of Smithville is tied in amazing ways to the Big Fork River.*

With this as a theme, the exhibits, programs, etc. would then give the visitors lots of different examples of just how Smithville is tied in amazing ways to the Big Fork River.

A theme is the one thing that, if nothing else, visitors remember, understand, or feel about the heritage tourism experience of your site, facility, program. The theme usually begins most programs, might be the first exhibit in a visitor center, or be the in the first introductory paragraph of a marketing brochure or self-guiding brochure.

Can you find the theme in this room of mixed graphics and messages?

Look at the graphic on the opposite page – this is what many visitors "see" when they enter a visitor center, museum, historic site, or other heritage attraction. They see "lots of things". But what you want them to see, in this example, is the perfect five-pointed star – that is the theme or main point we want them to understand. Can you find the perfect five-pointed star? How long did it take?

If you have trouble in finding the star, or the main point (theme) of this visitor center, look at the next page of this chapter for a hint. In heritage tourism planning, we want to make sure that the visitors can easily see the star (your main message).

Themes big and small

You can use themes for big messages and for small ones. For example, a theme for a historic home might be: *The Smith Mansion changed forever the way 18th century homes were built!*

An interpretive theme for a guided tour of the Smith Mansion might be: *The Smith Mansion holds many secrets behind its walls!*

Selecting your operational theme

So you need a heritage site theme – how do you pick one? There are several ways:

- Do a story analysis for your site or attraction – what is the site telling you it is a good or the "best example of ?
- What are the five most important aspects of your site (people, historical events, natural history, etc.) that happened here that you want visitors to know about?
- How can those five events or significant aspects of your site be summarized into one sentence (your star)?

Check your thought process. Ask yourself and your staff this question – and have each person write down their response: "If we spend all of this time and money to interpret this site's story to visitors, and after the end of their visit/tour they only remember one thing about this place, that one thing better be _____"! The filled-in blank is your theme.

Themes and marketability

Once you have developed some draft main heritage site themes, the next thing to ask yourself is "who cares". While you many think that your theme is great, will your visitors think so too? So as you develop your theme and site story messages, ask yourself these two questions:

1. Why would a visitor want to know this (come to the site, attend the program, etc.).
2. How do you want the visitor to use the information from your messages?

The theme needs to relate to your potential target markets – give them some reason or motivation to visit your attraction or facility, give them a hint as to "what's in it for them" by visiting the site.

Examples of heritage tourism site and community themes

Themes can be as rich and diverse as the kinds of heritage sites and attractions that are available for visitor to experience. Here

are some main theme examples. Note that there are no right or wrong themes. Simply themes that express your mission and site story in more market-successful ways than others. Remember – themes are expressed in complete sentences.

- The Connley Family (historic site) changed this communities history forever!
- The village of Elgen helped usher in the age of mass production.
- The town of George is a birthplace of inventors that changed the world of photography.
- The Wax River Fort Historic Site holds three hidden secrets.
- The industry of Tomsburg underwent three historic changes.
- Tomsburg milling history may have affected your own hometown.
- Protesting and preserving local history benefits you and your family in several ways.
- The daily lives of children in historic Smithville will make you laugh and cry.

Some examples of *program* themes (or sub-themes to the main theme) might be:

- The Smith home was built using three revolutionary building designs.
- Living in the Smith home was full of daily challenges.
- Fort George served the community in five different ways.

- Farming in Onionville in 1890 changed for two remarkable reasons.
- We need to preserve wetlands for 5 reasons.
- Wetlands benefit all of us in 5 ways.
- Steam engines changed our lives in 3 ways.

Main theme and sub-theme relationships

Once you have your main theme, you look at the sub-themes needed to illustrate that main theme. Here is an example:

Main theme

- Life on the Arnold farm changed in many ways in the early 1900s.

Sub-themes

- New kinds of farm machines changed farming forever.
- New kinds of crops were needed to be planted for cash crops.
- Three social changes of the 1900s affected the Arnold family in several ways.

So, essentially, themes are ways to organize and present the key story (and stories) specific to your heritage attraction, site or facility. They guide you to focus on the main events and to make sure visitors get a focused understanding of what is so unusual, important, special, memorable, etc. about your heritage site.

Summary

Heritage interpretive themes are an essential ingredient in

presenting your heritage attraction to visitors, and helping them understand, value, appreciate the significance of your site. The theme makes sure visitors get the big picture of your attractions story. Themes are short complete sentences that will guide your total program development (walks, talks, exhibits, etc.), as your interpretive services will need to be planned content-wise to illustrate your theme. Your theme is the essence of your identity, your thumbprint in the heritage or history of the area or community you are located in.

4

Developing Successful Partnerships: Planning Guidelines

Why do I need partners?

Developing partnerships for organizations and agencies in both the private and public sectors has been a management trend for the past several years. Particularly in times of tight budgets but growing demands for services, agencies have looked more and more to cost-sharing and work-sharing with groups and organizations. What can partnerships do for you?

- Provide cost-sharing for construction projects, exhibit projects, marketing services, staff training and development, and more.
- Provide credibility for some projects by having the right names associated with them.
- Provide expertise that may not be available in-house.
- Cut costs in marketing and advertising sites or attractions.
- Help in grant writing or other revenue generation.
- Help you accomplish your agency or attraction mission more cost-effectively.

These are just a few of the benefits of partnerships. But creating a successful partnership is not as easy as it might seem and there are pitfalls if the partnership doesn't work out.

Here are some things to consider in developing and maintaining successful partnerships.

Ten guiding rules for making partnerships work:

1. All partners must be equal. While the word partnership implies this, I have seen partnerships where one partner is more equal than the other in decision

making, management, or other issues. This can easily cause friction and the partnership to break up.

2. Benefits to each partner should be equal. All partnerships are based on the fact that each partner is looking to gain some benefits from the partnership. They may be benefits in marketing or advertising their site or resources, benefits in keeping their operation costs down, or other related benefits. If one partner seems to benefit more than the other, but the real costs of the partnership are equal, some friction can develop.

3. Partners should have some common or shared mission or organizational purpose. If all partners are after the same end (protecting historical sites, preserving the environment, wanting visitors to value the shared resource, promoting regional tourism, etc.), there is a greater chance of the partnership being successful.

4. All partnerships should have a written Letter of Agreement between the partners to spell out exactly the roles, duties, financial commitments, time frame commitments, management responsibilities, etc. for the partnership. This speaks for itself. All partnership agreements should be worked out clearly and in writing.

5. Choose your partners carefully: you are known by the company you keep. Will this partnership help or possibly hurt your agency or organization image? For example, if you are an environmental organization and have a partnership with an oil company – what will people think?

6. Talk to each other often. Some types of partnerships succeed or fail because of lack of communications between the partners. Depending on the kind of partnership you have, meet often to discuss common goals, strategies, or problems.

7. If you have a long-term partnership agreement (covering several years), have a yearly updating meeting to make any needed partnership adjustments. The key here is that tourists, agency administrators, budgets, everything – can change over time. Have flexibility built into your partnerships to make adjustments as needed.

8. Have a common or shared look. While you want to maintain your agency or organization identity, visitors are not really interested in who all the partners are. They do not want a quilt work of exhibit design looks, publication mismatches, or other visually confusing presentations. Agree on a common or shared look for a seamless presentation of a common or shared story.

9. Have clear deadlines or work plan timelines. If your partnership involves developing sites, attractions, exhibits, marketing materials, or other such joint projects, make sure that all partners can keep to shared work responsibility deadlines and project time tables. For example, if you are developing outdoor exhibit panels, and your designer needs graphic material from your partner by a certain deadline, make sure that the partner can meet these kinds of deadlines.

10. Try to like your partner. If you don't really get along with a potential partner, you will probably have problems along the way with the potential partnership. Some partnerships fail simply because the partners may have personalities that don't work well together. Successful partnerships take work!

There are different kinds of partnerships between different kinds of organizations and agencies and how partnerships might work between them vary greatly. From government agencies to commercial tourism attractions, to commercial service providers, to non-profit organizations – partnership benefits and arrangements will vary a lot.

Planning for partnerships

If you think that your organization or agency is ready for, or in need of, various kinds of partners, here are some steps for planning for your partnership. I recommend that you think through these questions before selecting or approaching potential partners.

Why do we need a partner?

How will a partner benefits us?

How will a partnership benefit the partner(s)?

- Financial Benefits
- Marketing Benefits
- Association benefits with our agency or organization.
- Gain access to a greater number of resources and expertise.

- Help them to accomplish their goals, objectives, or mission.
- Other.

What are the goals and objectives of our proposed partnership (what do we envision accomplishing via the partnership)?
- How will you know if the partnership is successful?
- How will you know if/when the partnership is not longer needed?

How will we administer the partnership?
- Who will write the contract or letter of agreement?
- Who will be responsible for any fiscal accounting?
- Who will be responsible for staff functions?

Do we need a long-term partner(s) or will this be a short-term partnership project?

Exactly what do we want our proposed partner(s) to do?
- Help with funding?
- Help with staffing?
- Help with administration of the project.
- Provide expertise?
- Provide credibility to the project?
- Provide in-kind services (printing, publications, etc.)?

Who are some potential partners? Make a list of the organizations, companies, attractions, etc. who you think

would make a good partner(s) based on the above criteria.

- How will we implement the partnership?
- What will it take to get things going?
- How will we evaluate the success of the partnership (for short or long term projects or working relationships?

Once you have thought through these questions (and answered them), then you are ready to approach your potential partners about entering into a partnership arrangement with you.

Summary

This chapter was designed to help you think through some of the issues and points that can make or break partnerships. In today's economy, partnerships, especially in the heritage tourism area, make good business sense. But like good business, it should be carefully planned and thought through to help ensure success.

5

Bringing 7000 Years of History to Life

What do ancient temples, Romans, The Order of St. John, seven UNESCO world heritage sites, *Cutthroat Island*, *Gladiator* and *Popeye* all have in common? They are all part of the Malta story. But first you are probably wondering just where is Malta? Nestled in the warm waters of the Mediterranean, Malta is about 60 miles to the Southeast of Sicily and about 250 miles to the Northwest of the coast of Africa. And to the thousands of tourists that come to Malta and its sister island Gozo, they find an overwhelming historic story with heritage sites spanning 7000 years of history waiting for them. You have probably seen Malta, or at least a part of it, already! Malta is a frequent movie location. The pirate movie *Cutthroat Island*, and *Gladiator* had portions of their film shot here. Also the movie *Popeye* with Robin Williams was filmed here. The village of Sweet Haven that features in *Popeye* still remains and has been preserved on its island location as a tourist attraction.

Why is interpretation seen as so important for Malta tourism?
Malta officially joined the European Union on 1 May 2004 with tourism having been given major importance through the country's deliberations on membership. In looking the tourism markets being attracted to Malta, the main market group was the "sun, sea and sand" groups. Malta beaches and resorts are first rate and thousands of cruise ship visitors embark to explore the island on almost a daily basis. But with the downturn in tourism since 9/11 and competition from other destinations for the sun, sea and sand markets, Malta tourism began to look more closely at the increasing and powerful

heritage tourism market. Heritage tourists are a different kind of tourist, seeking out different kinds of experiences and products. They want to stand, see and feel where history took place. And with 7000 years of history – Malta is a treasure chest of sites and experiences ripe for discovery. But a historic site without interpretation is just an old site. It is the interpretation of the story of the site – the who, what, when and why – expressed in a memorable, provocative and evocative manner that brings the story to life. Simply put, you can't really have quality heritage tourism without quality heritage interpretation to tell that site's story.

To this end, the Malta Tourism Authority feels that developing a more powerful heritage tourism market required excellence in interpretation as well. In November 2003 the Malta Tourism Authority sponsored its first-ever week-long interpretive planning training course, attended by representatives from many of Malta's main attractions and service organizations, including Heritage Malta and the Malta Tourism Authority. The intensive five-day training focused on what interpretation was, but more importantly, how to use interpretive planning and design principles in developing, marketing, and evaluating heritage tourism programs, services and media to accomplish real objectives.

What are The Malta Tourism Authority goals for interpretation? In general, the goals for interpretation in Malta are based on the general benefits interpretation can provide any heritage agency or organization using interpretation. These benefits can include:

- Interpretation shows visitors why the heritage site has value - to them (the visitor), to the community, and perhaps regionally or nationally.
- Interpretation can inspire visitors and create a sense of individual and national pride.
- It is the interpretation (programs, living history, guided tours, exhibits, etc.) that visitors come to the heritage site for - the story and site experience. Without interpretation a historic site is, in the eyes of the visitor, just another old site.
- Interpretation gets visitors to care about heritage (theirs or other cultures').
- Interpretive services are the reasons visitors come back to heritage sites.
- Interpretive programs and services can increase visitation by increasing the perception of benefits tourists receive by going to a particular heritage site.
- Interpretive programs and services can produce reductions in site maintenance, and related management issues when used as a management tool.
- Interpretive programs and services can make money!
- Interpretive programs and services provide added value to any heritage tourism experience, and heritage site marketing efforts.

Malta's interpretive experiences

Malta's current interpretive experiences run from the highly developed, to "successes waiting to happen", and to talk about

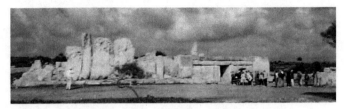

Figure 1: A group of tourists on an interpretive tour of Hagar Oim temple site.

all of them here would take hundreds of pages, so we'll just look at some highlights.

World heritage sites: Malta has seven of them, ranging from the ancient temples like the one at Hagar Qim, built in 2700 B.C. and the Hypogeum – a unique underground temple built in 2500 B.C, to the city of Valleta (Malta's capital) itself. The newly formed organization Heritage Malta is currently involved in bringing innovative and imaginative interpretation to these and related temple sites. Current interpretation is provided by tour group leaders with currently no on-site interpretation. This will change as future plans call for interpretive facilities and more self-guiding opportunities. These are some of the typical "successes in waiting" that will soon emerge as interpretive site super powers on Malta.

Malta's temples receive thousands of visitors a year, many arriving from cruise ships. Plans are in place to provide both self-guiding interpretation for these visitors, as well as conducted tours by trained interpreters as part of ongoing planning for better interpretive opportunities.

The historic city (and capital of Malta) Valleta began with

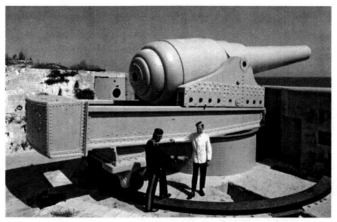

Figure 2: Living history interpretation of Malta's military heritage at Fort Rinella.

the cornerstone of the city being laid on March 28th, 1566, and was named after the Grand Master La Valette who led the Knights of St. John and the Maltese to victory over the Turks in 1565. Upon visiting Valletta Sir Walter Scott described the city as "that splendid town, quite like a dream". It still holds that same sense of wonder today, which is one of the reasons it is also a UNESCO World Heritage Site. Thousands of visitors go on guided heritage walks (interpretive tours) – many offered by licensed tour guides, through the city.

Besides its lengthy list of museums, galleries, and other unique and memorable experiences, Malta also has some other outstanding interpretive opportunities waiting and ready for visitors.

The Malta Experience, located in Valletta, is a must stop for any heritage tourist. Here through an audio-visual spectacular, you can witness Malta's unique 7,000 year history in just 45

minutes. This is the place to come for the big picture – and then decide which of the many sites and attractions you would want to go and see next.

Fort Rinella gives the visitors a totally different experience. Fort Rinella was built in the late 1800's at a time when the growing naval power of nearby Italy posed a potential threat to British commerce and navigation in the Mediterranean. The main feature of this Fort was its 100-ton gun batteries. The site and story of this important historic site in now managed by *Foundazzjoni Wirt Artna* (Malta Heritage Trust), which restored the site, and provides both self-guided, and on weekends "living history presentations and tours". We had the pleasure of attending one of the living history programs and found them to be of the highest interpretive quality, a feeling expressed by the many visitors to the site.

Working with transportation to create new and innovative interpretive experiences

Besides the traditional way of seeing Malta and its heritage attractions, interpretive opportunities that are under development include several historic transportation means around the city that are still in use today.

Karrozzin – or horse-drawn cabs (Fig. 3) – were once the main transportation means in Malta until the coming of the car. But they are still a favorite heritage experience. Depending on the driver, a visitor can not only get to their destination, but receive some first-hand interpretation of the history of the city too.

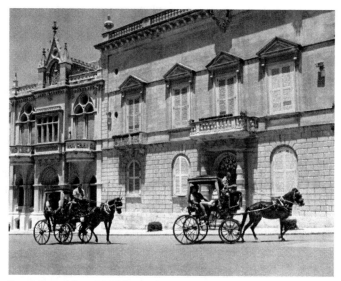

Figure 3: Horse-drawn cabs with first-hand interpretation

The *Dghajsa* – or taxi boat – has been in use in Malta for centuries. The *dghajsa* (pronounced *dye-sah*) is a brightly painted cousin of the Venetian gondola – each boat with its eye of Osiris, God of the Underworld, painted on the bows to ward off the evil eye. Today is it being developed as another unique Malta heritage tourism product, with the captains providing interpretation of the harbor and its history.

We can't forget the famous Malta Buses! While still providing transportation around the island for locals and tourists alike, these buses have their own character and historical stories. Malta Tourism has been working to develop interpretive bus tours with trained interpretive drivers to drop off and pick up tourists at destinations throughout the island. This is an interpretive experience in itself!

This is just a small sample of the more that 70 sights to visit and unique interpretive experiences, from historic churches, cities and villages, to forts, harbors, and museums, that waits for Malta visitors, with interpretation becoming more important for each.

Malta Tourism Authority's goals and vision
The main goals for Malta interpretation include:
- Continue to provide interpretive training for commercial and non-profit tourism providers.
- Use interpretation principles more widely in heritage tourism development and marketing.
- To insure the quality of the interpretive experience.
- To provide interpretive training for Malta's Licensed Tour Guides.

Summary
Malta is a treasure-trove of interpretive experiences, stories and visions reflecting over 7000 years of history. The heritage tourist will have to spend weeks here to see and do it all, and interpretation will be the cornerstone to help make Malta's many stories come to life for visitors. But more than that, interpretation will be a key part of Malta Tourism marketing strategy to help lure more heritage tourists to this enchanting location. The sun, sand and sea are still here too, but now heritage will be an ever-growing part of the Malta Tourism market – with interpretation in the forefront to help that happen.

Acknowledgements

We would like to thank the Malta Tourism Authority and Heritage Malta for their support and photo contributions for this chapter. For more information on Malta, visit their web site at: http://www.visitmalta.com.

Further reading

Malta Prehistory and Temples, by David Trump and Daniel Cilia.

Malta & Gozo - Sun, Sea and History by John Manduca

The Hal Saflieni Hypogeum - Edited by Anthony Pace - National Museum of Archaeology, Malta.

6

Interpretation as a Management Tool

The idea of using interpretation to help accomplish management objectives is relatively new, but gaining in use. Originally interpreters main jobs were to serve as entertainment directors for parks, historic sites, etc. Most of the early photographs of interpreters or "naturalists" usually had them pointing at something – flowers, geological features, historic structures and so on. And in most professional job settings we were expendable. Whenever there was a budget problem, the interpreters in the agencies were the first to go. After all, they didn't do anything essential. The agencies, or the interpreters themselves hadn't realized the true potential and value of interpretive communications.

Interpretation as a management tool?

To look at how we are using – and can use – interpretation to help with management issues, it is first important to remember that interpretation is an objective-based communication process. We usually have three kinds of objectives interpretation focuses on accomplishing:

- Learning objectives
- Behavioral objectives
- Emotional objectives

The learning objectives are designed to provide basic topic information or understanding, such as "The majority of the visitors will be able to describe three reasons protecting archaeological sites benefits all visitors".

But the real objective, or most important objective, the

manager may have in mind for interpretation to accomplish is to prevent visitors from picking up "souvenirs" at archaeological sites, such as pottery shards. So the behavioral objective might be: "All visitors will leave any artifacts they may find at the site alone and not pick up any artifacts to take home with them".

It is the job of the emotional objectives for the interpretation to get visitors to appreciate the value of artifacts left in place, and feel that they are doing a good thing by not touching anything. So an objective of this kind might be: "The majority of visitors will feel a sense of responsibility for not touching any artifacts they may find on the ground". Or "The majority of visitors will feel good – a part of the resource protection – by not touching any artifacts they may see on the ground".

The relationship between the behavioral objective (the results-oriented objective) and the emotional objective is that the behavioral objective is the thing you, as a manager or interpreter, want to have happen as a result of the interpretation (how you want the visitor to *use* the information you are interpreting to them). The emotional objective forces you to plan how you will get the visitor to feel that the behavioral objective you have in mind is something they should want to do.

This is the same basic strategy used in advertising today. The advertisement in a magazine wants you to do or buy something. The presentation of the ad – the graphics, the way the ad relates to different market groups, the evidence the ad portrays as to why you need this product or service,

follows this same format. The emotional objective of the ad is to make you *feel* you want or need this particular product. The behavioral objective is for you to actually go out and buy it.

What management issues can interpretation help with?

The US Army Corps of Engineers has embraced interpretation into its day-to-day communication with visitors. Interpretive programs and services are used to:

- Help promote water safety issues (wearing Personal Floatation Devices, not drinking alcohol while boating, swimming safety) and many other safety issues as well.
- Help protect cultural sites or resources from vandalism.
- Help visitors understand various resource management programs and activities.

The US Forest Service is using interpretation in many National Forests to communicate with its visitors about a variety of management issues, including:

- Wilderness hiking safety and stewardship issues.
- Understanding ecosystem management and the benefits of this management approach to the environment, communities, and the visitor.
- Reducing vandalism and littering.
- Protecting historical and archaeological resources.
- Helping to instill a sense of ownership and pride in local resources or history to gain community support of various management programs and policies.

- Incorporating interpretation into its general Heritage Tourism planning program.

Many other agencies are finding that interpretation programs can (and do) help combat problems of vandalism and depreciative behavior in parks and forests. Interpretation is also being used in general recreation management strategies, to help the visitors have a safer and more enjoyable recreation experience. Other studies are finding that interpretation programs can help reduce litter in parks and forests.

In general, interpretation can be used (and is being used) for a number of management areas for parks and historic sites. These main areas of use include:

- Pre-visit orientation for visitors.
- Visitor flow into and through areas (via trails, developing other use areas, interpretive directional signage, etc.).
- Serving as part of the forest marketing or tourism plan.
- Reducing litter and vandalism problems.
- Interpreting on-site safety concerns.
- Resource protection (natural and cultural)
- Helping visitors understand and value resources and the management programs in place to protect or preserve those resources.
- Providing awareness of environmental issues or concerns.
- Encouraging visitors to take a pro-active role in site/ resource protection.

- Becoming the cornerstone in regional heritage tourism programs.
- Gaining community support for the site/resource.
- Providing structure for tourism planning and program implementation.
- Agency image and recognition.

The bottom line

Today managers are seeing that interpretation is *not* just the frosting on the cake but in many instances, the cake itself. Interpretation is the most powerful and effective communication process any agency has available to it for communicating any message to its publics. Interpretation is designed to get results!

For example: Let's say an interpretive program costs $1000 to present (staff time, preparation, materials, etc.) over the length of a summer (90 days) and that over that 90 day period 3000 visitors attended a program on *Litter affects all of our lives!*. The cost per visitor contact for that program is 33 cents. To determine if the program is cost-effective you have to look at what is being accomplished for that 33 cents. If your main behavioral objective was to have visitors litter less, or pick up other litter, you might look at your maintenance (litter pick up) costs for the past year. Let's say that last year your litter pick up costs for your site/agency was $5000 for the same 90 day period. But at the end of this year's 90 day period for which you had your anti-litter programs going, the cost of litter pick up is only $3000. Making the assumption that all variables are

the same except for this years anti-litter program, the reduced costs for litter pick up were probably related to the interpretive program. The program saved the agency total of $2000 in maintenance costs.

The program cost $1000 to present for the 90 day period and helped the agency save $2000. So for the cost of 33 cents per visitor contact for this management-related interpretive program, the agency made 33 cents per visitor contact in reduced litter pick up costs. This is an example of how to both use interpretation as a management tool, and illustrate cost-effectiveness of the cost per contact in using interpretation to help you get more funding for other types of interpretive programs.

This is the kind of business thinking that interpretation is beginning to generate in the best resource managers and interpreters. Interpretation can really work for them!

The need for research
While this is a growing area for using interpretive services, there are very few documented results. We know of lots of examples where everyone knows the positive effect of interpretation as a management tool, but few of these programs have been studied thoroughly, and published in academic journals. If you or your agency are using interpretation as a management tool, document the process and results, and share your information with the profession – you may be on the cutting-edge of interpretation practice and not even know it!

Summary

For the past few years, more and more agencies are using interpretation as their first line of communication with their visitors. And more agencies are discovering the power of using interpretation in helping to accomplish their management objectives as well. Interpretive communication is the most powerful communication process any agency has available to it to communicate with its visitors! Using this powerful tool to help communicate with the visitor about management issues is increasing. Its not just a good idea – its good business.

References

Bright, Alan D., Manfredo, Michael J., and Baseman, Cem. 1991. Implications of persuasion theory for interpretation. In: *Proceedings of the 1991 National Interpreters Workshop.* Madison, WI: Omnipress, 40-45.

Dustin, Daniel, Christensen, Harriet, and Namba, Richard. 1989. Designing interpretive messages to combat vandalism and depreciative behavior. In: *Proceedings of the 1989 National Interpreters Workshop.* Fort Collins, CO: National Association for Interpretation. 214-217.

Hooper, Jon K. and Weiss, Karen S. 1990. Interpretation as a Management Tool: a national study of interpretive professionals' views. In: *Proceedings of the 1990 National Interpreters Workshop.* Nacogdoches, TX: School of Forestry, Stephen F. Austin State University. 350-357.

Roggenbuck, Joseph W. and Ham, Sam H. 1986. Use of information and education in recreation management In: *Literature Review: President's Commission on Americans Outdoors.* Washington, D.C. US Government Printing Office, management, 59-71.

Veverka, John A. *An Objective Look At Interpretation.* John Veverka & Associates, Interpretive Training Division. Occasional paper #1, 1993.

7

An Introduction to Interpreting Cemeteries and Gravestones

I first became interested in gravestone and cemetery interpretation many years ago while attending an Association of Interpretive Naturalists regional meeting in Indiana. One of the events included a visit to Spring Mill State Park and discussions about their cemetery interpretation which was an outstanding experience. Since that time I have been involved with community interpretive planning as part of heritage tourism development. For all of the communities I have worked with, some interest in interpretive services for their cemeteries always came up. In fact, cemetery interpretation and gravestone interpretation is very popular and growing in interest. Some cities, like the community of Belvidere in Illinois, incorporate cemetery interpretive programs, both guided and self-guided, into their community history and heritage interpretation. The interpretation here not only includes the symbols and meanings of the stones and their designs, but the historic founding fathers and key historical figures from the community. These programs are highly attended and very successful.

In addition to the wealth of unusual grave stones in the Belvidere Cemetery, the Cemetery also has some unique architecture as well, the Frank Lloyd Wright Pettit Memorial Chapel – a historic facility built in 1907 that is still being used, and currently under restoration. This is an important part of the total cemetery interpretive program.

Planning for Cemetery and Gravestone Interpretive Programs
If you are interested in providing a community heritage

interpretation program using a local historic cemetery, here are some steps to consider:

- Remember that this is a cemetery. Any and all interpretive guided programs or tours, and self-guiding interpretation must be respectful of the site you are in.
- Check into the need to acquire permission to use the cemetery.
- Be mindful of how many visitors you could manage in the cemetery at any one time, and any damage that might occur (soil/grass erosion, etc.).
- Plan your objectives well – what do you want the interpretive programs to accomplish?
- Clearly plan what elements you want to interpret:
 - Gravestone art/designs and their historic meanings.
 - Gravestones as a social statement.
 - Gravestone carvers
 - Historical figures from the communities past.
 - Communities relationships to conflicts (Revolutionary War, Civil War, etc.).
 - Social stories and conflict (where were the black community members buried?)
 - Funeral practices (above ground vaults, wooden caskets, etc.).

Once you have decided upon what elements you want to interpret, begin your research into that subject. I will provide

some excellent references and web sites at the end of this chapter to help get you started.

Some small community cemeteries can be very powerful even if they are lacking in gravestones. The Dougherty-Miller Cemetery located in Jefferson County (not far from Madison), Indiana is an example of this. I visited the cemetery site as part of developing a regional community interpretive plan for Jefferson County.

This cemetery, for blacks in the late 1800's, was almost lost amongst the trees. The site is now being cleared and restored. When you walk into a site like this one, and have first person interpretation of who, what, when, and why, it is sad and sobering. The day I visited the site a light snow had fallen, highlighting the many grave sites without any markers. This is a powerful and important part of local history, and the interpretive experience here will send chills down your back – and the memory of your visit will linger. There are only a few headstones showing today, like the one below, of a black civil war veteran who could only be buried here.

The story on the stones: symbols and their meanings

Of course, one of the most interesting parts of gravestone interpretation for most visitors is the use of art and symbols on many older stones. This is something that will need to be researched for any cemetery you might be interested in interpreting, as there is some change in designs and types of symbols used over time. There is also a design change as you look at cemeteries from the east coast and move west. So you'll

need to find out just what part of the gravestone art story you have. There are lots of reference books for that, but here are some very common symbols.

Another common design on gravestones is the hand/finger pointing up. This symbolized the pathway to heaven, or heavenly reward.

Yet another common gravestone symbol is the use of clasped hands which symbolizes farewell or hope of meeting in eternity.

Flowers are also a common symbol. They were common on women's graves. The flower symbolizes life's frailty and immortality. Of course, some of the older gravestones in New England can have some exceptional carvings on them, such as the use of skulls, which symbolize the transitory nature of earthly life, penitence, and mortality.

But some gravestones can be much simpler, and may lack any art work at all. Some stones may have been done on a budget, the family not being able to afford a well-known stone carver, not have a stone carver available or the stone work was done by a family member or friend. One stone, from the Belpre, Ohio Cemetery and dating from 1804, has an epitaph which reads: *Death is a debt to nature which I have paid, and so will you.* Note that you can have an interpretive program just based on epitaphs!

Of course, these are just a few of the common symbols that you might find on older gravestones, there are hundreds of different designs and symbols. Here are just a few symbols and their meanings from the website *Tomb With A View's Guide to*

Commemorative Motifs, Mourning Images, and Memento Mori:
- Anchor: hope, seaman.
- Angels: rebirth, protection, wisdom, mercy, divine love.
- Bird: eternal live, winged soul, spirituality.
- Chain with three links: Trinity, faith, Odd Fellows
- Column: noble life
- Frog: worldly pleasure, sin.
- Ivy: fidelity, attachment, undying affection.
- Poppies: eternal sleep.
- Rope circle: eternity.
- Rose: victory, pride, triumphant love, purity.
- Tree: life, knowledge.
- Tree trunk, leaning: short interrupted life, mourning.
- Urn: immortality, death of the body and its return to dust.
- Wreath on skull: victory of death over life.

This has just been a sampling of the interpretive possibilities for cemeteries and gravestones as part of community heritage interpretation and tourism development. In Freeman Tilden's terms (*Interpreting our Heritage*, 1954), this is something we can all *relate* to as, eventually, as one gravestone noted: *As I am now, you shall be too!* This can be one of the most powerful tools we have for interpreting the true nature of our communities, and our heritage. The stories are all there: people, events, folk art, a history textbook carved in stone waiting to be read.

I hope you will consider this aspect of community or

historic interpretation if it is appropriate to your site or stories. The interpretive experience will be powerful and memorable, helping visitors and local residents alike truly understand their local history. Here are some references to help you get started.

References

Ludwig, Allen. *Graven Images: New England Stonecarving and Its Symbols 1650–1815*. Wesleyan University Press, Hanover, NH.

Ridlen, Susanne S. *Tree-Stump Tombstones: A Field Guide to Rustic Funerary Art in Indiana."* Old Richardville Publications, IN

For other information on cemetery and gravestone studies contact:

The Association for Gravestone Studies

Greenfield Corporate Center

101 Munson Street - Suite 108

Greenfield

MA 01301

USA

www.gravestonestudies.org

8

Guidelines for Interpreting Critical Issues

Interpretative communications has been gaining in use by agencies and managers for interpreting management issues and for a variety of public relations functions. We know that interpretation is the most powerful communication process we have available to us to use to communicate to our visitors with. Interpretive communications thus becomes a first line of communication with visitors about critical management issues that may arise for any resource management agency.

What is a critical issue?

For the purpose of this chapter, critical issues are defined as topics that deal with resource problems and their need for solutions that relate to the safety of the visitor at the resource site or relate to resource protection and management issues that the public needs to be aware of.

As examples, critical issues may include, but not be limited to:

- Water safety issues (boating, swimming, etc.).
- Resource management of endangered species or habitats.
- Resource management of fragile resource sites (sand dunes, bogs, etc.).
- Resource protection for cultural or heritage sites.
- Visitor safety issues related to wildlife encounters.
- Fire prevention.
- Visitor safety for extended back country or wilderness hiking.
- Mountain Lion sightings within a park or forest.

- Interacting with bears or other park/forest dangerous wildlife.
- Public relations issues (trail or site closings, upcoming management programs such as timber harvests, prescribed burns, etc.).

Developing a critical issue interpretation strategy

Analysis of the issue

The first step in developing a interpretive strategy for a critical issue is to determine what the critical issue is? Here are a few things to consider:

Critical issue for who? Is this an issue that has been determined critical by the agency because of apparent resource problems, or is this an issue that has been raised by the visitors and their reaction to some management practice or other agency policy?

If the resource agency has deemed the issue critical, such as potential damage to a fragile habitat by hikers, some of the *Who?* considerations include:

- Does the issue relate to all visitors, some visitors, the staff?
- Is this a short term problem, seasonal problem, or year-round problem?
- Are visitors currently aware of the problem or issue and its relationship to them?

Why is this issue critical? Determine what you mean by critical. Does the problem or issue need to be addressed for

immediate action, such as the problem with a fragile habitat being damaged, or is it a more long term critical issue, such as yearly damage to historic resources. You should think about these questions as you begin to develop your interpretive communication strategy to address the issue to the visitors:

- Is this a new problem?
- Is this an old problem? If it is, why have other proposed strategies to address the issue not been successful.
- What has changed or happened to make the issue critical now?
- What are the consequences if nothing is done?

What are the individual parts of the issue? Every issue has many parts to it. These include what has happened to create the issue, who the specific target market (audience or user groups), kinds of resource management strategies that visitors will need to be a part of, and interpretive media needed to communicate with the visitors, both for short term and long term issue presentation.

Specifically, what needs to happen, and when, for the issue to be resolved or successfully treated? What is the work plan timeline? Are there immediate needs, such as temporarily closing a trail so the environmental damage will stop until a more permanent solution (such as a boardwalk that allows visitors access while protecting the habitat) is put in place?

Developing a change strategy plan

Depending on the critical issue you are addressing you have to

be aware that, in some cases, change in the visitors attitudes and perceptions may take months or years, and cannot change overnight. Other issues may be interpreted and have some immediate success, as long as the visitors understand and agree with the interpretation of the issue.

Here are some of the main points you will need to consider as part of your Change Strategy Plan:

1. Identify what it is you want to have happen as a result of the interpretive program(s) on the critical issue. Develop specific objectives to be accomplished.

2. Do a Target Market Analysis: *Who are the target markets the message(s) will be addressed to?* What is their current opinion about the issue, if any? You can't begin to try to change visitor attitudes or perceptions about an issue unless you first understand what their attitudes or perceptions are! *Why should the visitor do the things you want them to do - what's in it for them (benefits).* This is probably the most important item to consider in developing your interpretive program or exhibits. This is the one that the visitors will relate to the most. *How long will it take for the visitors to react to the interpretive message and how many times will they need to hear or receive the message?* In other words, do you think one program or interpretive panel will help the visitor understand the critical issue and their role in solving it, or will it take many messages, in different formats, over a long period of time?

3. Determine when you need to see results by – is that

time realistic?

4. How will you verify that the objectives of the critical issue presentations are being achieved (evaluation or tracking strategy)?

5. What will it take to implement the interpretive programs or services for the critical issue presentations to the visitors? Time, money, staff, political or administrative support, etc?

6. How long do you project the interpretive programs, exhibits, etc. to have to stay in place for the new desired visitor behavior, attitude or beliefs to *hold* at the desired level? Some issues, like littering, may need to be interpreted every year, without end to keep the message active.

The hierarchy of change

Change usually doesn't happen very quickly, and there are several steps to the change process as illustrated by Figure X.

In this strategy, assuming the visitors are not already aware of the critical issue you are focusing on, you must first begin with awareness of the issue by the visitor. With our trail users damaging a fragile habitat example, the visitors may not be aware that they are the problem, or that a problem even exists. This is your first step – make them aware.

Secondly, as you develop and present your program or media over time, and the visitor sees and learns more about the issue, they will begin to feel something about what you are interpreting to them. This can run the full range: from feeling

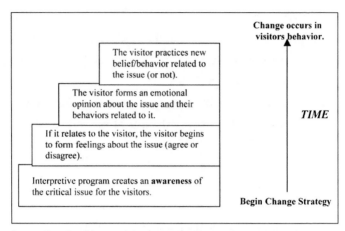

Figure 1: Hierarchy of change in behavior over time.

sad about the issue, to feeling angry, to feeling the need to help the resource managers to "no feelings about the issue at all"! With our trail example, they may feel angry that they cannot temporarily walk the trail until a boardwalk is constructed over the damaged habitat, but also feel that it is the right thing to do and support the decision to close the trail. It is a matter of the quality of interpretation of the issue and how well it can be make to *relate* to the visitors, such as illustrating the *benefits* to them and the resource by this management action.

There is a transition from the initial development of feelings or initial opinions about the critical issue to the formation within the visitor of a definite opinion or set of beliefs about the issue. If their new beliefs are strong enough, you may be able to expect them to begin to put into practice or support the needed actions that will help resolve the critical nature of the issue fairly quickly.

Again, it is also important to remember that change (getting results) from your critical issues interpretation may take time. Depending on the issue, this can range from immediate action, to taking months or years. *Evaluation is critical too!* As part of the total change strategy for the critical issue you are working with, be sure to have a method of tracking or evaluating the success of your interpretation of it. This should include pre-testing any interpretive programs or media to see how visitors react to the message presentation before you go to the final expense of making interpretive panels, exhibits, or interpretive programs.

Summary

Interpretive communications is the most powerful communication strategy we have available to us to use to interpret critical issues to our visitors. We must be clear on what the critical issue is, and the role of the visitor within the issue. We must also be clear on what exactly needs to be done to correct or uncritical the issue we are interpreting, and the specific results we are expecting from our interpretive programs or services. We also need to be aware that quite often real change takes continued programming effort, and time.

9

Interpretive Communication: The Key to Successful Heritage Tourism Marketing Planning and Program Design

You already know what Interpretive Communications is! You have seen it on TV, heard it on radio, and seen it used in magazine advertisements. So why don't you recognize it? Interpretation is the most powerful communication process we have available to us to communicate to our market groups with! Are you *provoked* to learn more? Good! That's one of the first principles of interpretation.

Interpretation as a profession began back in the 1950s in the National Park Service. The guiding principles of interpretation were penned by Freeman Tilden in his book *Interpreting our Heritage* (1957) and became the communication strategy used by Park Service naturalists (now called interpreters) in conducting their public tours and programs. Interpretation is defined as: a communication process designed to reveal meanings and relationships of our natural and cultural heritage, to the public (or our visitors), through first hand involvement with objects, artifacts, landscapes or sites.

Today interpretive communication strategies are used by educators, interpreters, and communication professional working in a wide range of visitor contact areas such as museums, zoos, botanical gardens, parks, historic sites, urban interpretive sites, factories, scenic byways – any place we want to interpret the story or essence of a site to visitors.

Professional interpreters translate the story of an artifact, site or other related message from the language of the expert to the language of the visitor. And this is where interpretations role and its key importance to heritage tourism begins.

In interpretation, the structure of the interpretive

communication, from live program to brochure or exhibit design, follow this simple, yet powerful strategy.

The message must:

- Provoke the attention or curiosity of the visitor/audience. If you can't get their attention or interest, you can't communicate with them.
- Relate to their everyday lives or experiences. We must communicate to them in terms and examples that they can understand.
- Reveal the essence or key parts of the message last – we want an "oh my" response.
- Strive for message unity: se the right colors, design style, music, etc. (stage setting) to support your total message presentation.
- Address the whole: illustrate how this specific interpretation is part of a larger picture, such as how this historic home is an example of a larger community story.

These are the guiding interpretive principles in constructing an interpretive message. This format for communication success should sound familiar. It is the message structure for a *Paul Harvey Rest of the Story*, and the communication structure for almost all advertisements you have ever seen. In commercial terms, this communication process tells you:

- Why you need this product (provoke).
- How this product will benefit you (relate)
- How little it costs and how easy it is to do/acquire (reveal).

- Why other people just like you are using it/buying it (relate & reveal).
- This is another fine product brought to you by...! (Address the whole – show how this is from a family of related products or company image).

Interpretation for heritage tourism planning.

Based on the interpretive principles, interpretive planners also have a formal planning model for success – again also used in marketing and advertising. In simple terms, our planning format considers:

What? Is the story, site, or message to be interpreted to visitors.

Why? What are the specific objectives (learn, feel, do) that the interpretive message(s) is being designed to accomplish?

Who? Are our target markets, what are their interests, demographics, visitation or use patterns, what are they looking for in a heritage tourism setting. What will be required for the story presentation to *relate* to these specific audiences?

Media: What kinds of interpretive programs and services will we need (live historical interpreters, guides, self-guiding leaflets, audio, visitor center exhibits, etc.)

Implementation and operations: What will it cost, what will it take to implement the marketing or programs, who will do it?

So What? Evaluations, pre-testing, feedback. Were the objectives accomplished (was the marketing, programs, tours, etc. successful – why or why not?).

The two key questions in developing heritage tourism

programs or services for the public.

We often forget that we are developing heritage tourism opportunities for visitors. It is important to understand them as well as we understand the individual sites we want to attract them to. In marketing and planning heritage tourism opportunities, we have to ask:

1. Why would a visitor want to know (do) this?
2. What do we want them to do with the information we are interpreting to them?

As we look at these two questions, the first question reflects back on our interpretive principles of provoke and relate. If visitors aren't interested in learning about historic forts, or the sites along a scenic byway – they won't want to do the experience. Interpretation works to create interest and tell the visitor how they will *benefit* from it. They would want to know this information because they will get a return on their investment of time, money, and recreational learning.

The second question is one of product – what do you want in return for your heritage interpretation/tourism investment? Do you want visitors to stay longer, buy items from gift shops, gain support for preserving important sites, get visitors to become volunteers, encourage visitors to use the site in a safe and stewardship-like manner? There are no right answers to these two questions. The answer will differ depending on your site or project. But the answers are important in planning your total heritage tourism marketing and presentation efforts.

The product of the product!

This is another key element for interpretation helping to make heritage tourism efforts successful. The product of the product is a main planning concept for any heritage tourism marketing plan, and interpretive program/services planning.

By selling the product of the product you put the context of the message in terms that the targeted user will better understand. For example:

- Are you selling drills or holes?
- Are you selling cosmetics or hope?
- Are you selling cars or social status?
- Are you selling scenic byways or community heritage?
- Are you selling historic houses or the value of preserving them?
- Are you selling things or experiences?

This concept is, to me, the most important part of heritage tourism marketing and presentations, and another reason why it will have limited success without interpretive communications.

Interpretation is product-based!

We must understand what it is that we are selling as our heritage tourism products, because we plan and design all of our interpretive media and services to focus on that final product. What is the product of the scenic byway experience, for example? Do you really think that visitors will want to memorize all of the information about the historic buildings,

forests, gardens, etc. that they will see? Why would they need to know this? Or are you really selling as a product of the byway drive – a beautiful and scenic experience that illustrates the value to communities in preserving their heritage. The historic sites, industry and nature the byway interpretation reveals to them all are examples of this larger story.

If you are doing any form of heritage tourism, you need to be product-based, and experience-based. Because the bottom line is that you are only marketing one thing as your product to visitors – benefits!

What is/are the benefits of doing a scenic byway tour? What are the benefits to a visitor for visiting a historic shopping district? What are the benefits to the visitors in visiting a historic village, a nature center, a zoo, a garden? If there were no benefits to the visitor, then why would they want to go there? If there are no benefits to visiting a heritage tourism site – don't be surprised if no one shows up. Visitors select their heritage tourism visits after comparing one opportunity to others – finally selecting the one that has the best benefit package to them (distance from home, total costs, things to see and do, unique experiences, something for all family members, food service or other needs, intrinsic values or interests, etc.). This takes us back to our heritage interpretation planning. We must understand our audience, understand how to provoke their attention, relate to their (target market) needs, and reveal the many benefits or rewards waiting for them if they select a particular attraction or experience.

Then when the visitor arrives at the site or attraction, the

on-site interpretive programs take over to produce the array of products the visitor came for (fun, be part of something special, see something special, have unique experiences, etc.). The bottom line – Interpretation makes Heritage Tourism Successful and meaningful.

So why is interpretation critical for the success of any heritage tourism project? Here are six reasons:

1. Interpretive communications is based on communication principles from marketing, advertising, consumer behavior, recreational learning and other successful communication strategies – *it works!*

2. Interpretation is objective-based – we want measurable success.

3. Interpretation is audience-based – if you don't truly understand your audiences or potential audiences you will only have marginal tourism marketing success.

4. Interpretation is product-based (the product of the product). It helps you focus on what it is you are *really* promoting to visitors.

5. Interpretation is benefit-based (as products). Interpreters know that if there are few heritage tourism benefits for visitors to come to a particular site, the visitors will probably go someplace else with a better benefit package.

6. Interpretation is the *most* powerful communication process you have available to you to communicate to your market groups with!

Summary

In this chapter I have provided a brief overview of the importance of interpretive communications to any heritage tourism effort. It is interpretive communications that speaks directly to and with the visitor. Interpretation helps visitors to understand, appreciate, value, and care for our (their) cultural and natural heritage. It provides the visitors with relevance, and makes them feel a part of the experience. A historic home without interpretation is just an old home. A Scenic Byway, without interpretation, is just a road. Interpretation gives heritage sites life, and visitors a story to experience and feel good about.

Having interpretation as a key part of any heritage tourism effort isn't just desirable – you probably can't have a truly successful heritage tourism program without it!

Hopefully this has provoked you to want to learn more about and use interpretation, related to you specific reasons why you need it, and revealed the many benefits you will gain from using it. After all: interpretation's product is *your* success!

10

Interpretive Planning
For The Next Millennium

*It's easy to come up with new ideas; the hard part is letting
go of what worked for you two years ago, but will soon be
out-of-date.*

When we do interpretive planning – what are we planning for?
In the old days (a few years ago), most interpretive planning
involved a simple process. When we were doing an interpretive
master plan for a park or historic site, for example, we looked
at the resources or landscape, and the main interpretive
message, and planned what interpretive services or media
would go where to best illustrate the story. So interpretive
planning was focused on two main elements: first, the story or
main interpretive theme/message; and then ultimately, which
media or service to employ at particular locations within the
site. Interpretive planning was more focused on the place than
on the visitor.

Objective-based planning

As our experiences with planning evolved we began to look
at the outcomes from our interpretive planning efforts.
What were we *really* accomplishing? So we began to employ
objectives for all our interpretive services and media: learning,
behavioral, and emotional objectives. We began using these
three levels of objective-based interpretive planning not
because it was just a good idea, but because our clients wanted
some proof that the interpretive plans (the media and services)
were actually working! For example, if you were going to pay
thousands of dollars for interpretive panels, wouldn't you be

interested in knowing if the visitors actually got the message from the panel? It is hard to evaluate any interpretive program, service or media if you don't know what it was supposed to accomplish in the first place – that's where objectives come in. If an interpretive panel was designed to have "the majority of the visitors be able to describe the three ways trees benefit people", we could pre-test visitors to see if they knew the answers – and then post-test visitors after they saw/read the interpretive panel to see if there was a real increase in knowledge.

This level of interpretive planning then led us to a more advanced level of using objective-based interpretive planning – *cost-per-contact and cost-effectiveness* of the interpretive programs and services we recommend, design, and build. That means that our clients were not just interested in "did the visitors remember the information", they wanted to know if they (the organization, agency or facility) were getting a return on their interpretive media or service investment. A new way thinking about interpretation. Now it was not just an information transfer that was the focus, but "what did we get in return for our investment of $10,000.00 in interpretive panels? Why should we spend money on interpretation if nothing happens?" So we were now doing interpretive planning to predict just how cost-effective each proposed interpretive program, service, or media might be. The key question of the clients: "if we spend $1.00 on interpretation services or media, will we get at least $1.00 in benefits from that media or service?" In particular, we are now looking at

interpretation results (from our learning, behavioral and emotional objectives) that can be demonstrated to:

- Benefit the resource (less litter, reduced vandalism, reduced erosion, etc.).
- Benefit the agency (visitors can identify the managing agency, understand their management strategies for the site, support the agency and its programs, etc.).
- Benefit the visitors.

Note that for the interpretation to be truly successful, all of the above must happen.

Benefit-based planning

This new evolution had led us into new interpretive planning strategies where the most important of our objectives were now the behavioral and emotional objectives or real outcomes. When interpretive planning begins for a project, we ask ourselves for every objective we develop for an interpretive program, exhibit, media or service:

1. Why would a visitor want to know this?
2. How do you want the visitor to use the information you are giving them?
3. What are the benefits (to the resource, agency, visitor)?

In other words, how will the visitors benefit from the interpretive program, media or service experience? And, is the cost of the experience (like a self-guiding tour) at least equal to the benefit package that is a product of the interpretation.

So, just what are the benefits to the visitors, the resource, and the agency from spending $5,000 or more to develop a self-guiding interpretive trail – or $500,000.00 for visitor center exhibits? The sad point is that in the past – and even today, this is not often considered. But the question remains – if it was your money, would you spend thousands of dollars for interpretive stuff without first knowing what you got in return for that investment?

The reality test – go out and look at any interpretive media/services you may have at your site – exhibits, outdoor panel, self-guiding tour, etc. Now ask yourself – how is this particular media or service helping us accomplish our mission? Was it a good investment to spend $2000.00 on an interpretive panel with information that the visitors likely quickly forget? How is this helping protect the resource, or instilling a sense of value to visitors, or helping the agency accomplish its educational or management objectives? Apply the questions to any of your media – from zoo signs, to historic sites, to parks. The answers you come up with will reflect the state of the art of the interpretive planning that produced that media or service at that time.

The product of the product – and other messy ideas.
I think of the *product of the product* concept as a "messy" idea because it is another evolutionary step for interpretive planning that messes up the way that we've always done it. Here is how the concept works: by selling the product of the product we present the idea in a context that the potential

visitor knows and understands. For example:

- Are you selling drills – or holes? Because if the customer doesn't need a hole, they don't need a drill. The hole is the product of the product (the drill).
- Are you selling cosmetics – or hope? Do the advertisements for both men's and women's cosmetics for example just sell the hair coloring gel – or what will happen to you after you use the product (feel younger, happier, more attractive).
- Are you selling automobiles or status? Watch a car ad on the television – who is driving the car – were are they driving the car to? What socio-economic bracket is being marketed to? What is the status of the people in the advertisement?

Now let's apply this product of the product concept to interpretive planning :

- What is the product of a self-guiding trail walk?
- What is the product of visitors reading your interpretive panels?
- What is the product of your visitor center exhibits?
- What is the product of your guided interpretive walks or tours?

What is happening now is a new way of thinking about how to do interpretive planning. We clearly understand the outcome(s) we want to have happen (our objectives) before we plan and design the programs or services for a given site. We

select locations, media, services, etc. to accomplish and realize the desired outcomes. We do not say "let's put a trail here, or a viewing station there" unless we know what the outcome (product) of that media or service has to be. Our desired product of the product helps form our learning, behavioral and emotional objectives that guide our research and design, and can be evaluated (pre- and post-tested) to see if we indeed get the outcome or product that we originally desired.

Now comes the Experience Economy – are we ready?

The latest formal addition to our interpretive planning philosophies is that of experience-based interpretive planning. In their book *The Experience Economy*, B. Joseph Pine II and James H. Gilmore looked at the value of experiences and experience as a marketable commodity. This concept translates very well to interpretive planning. Here is what experience-based interpretive planning involves.

When a person buys an experience, they pay to spend time enjoying a series of memorable events that a site or facility stages to engage them in a personal way. - Pine and Gilmore

That means that we are not just planning for outcomes (our objectives being accomplished at the end of an interpretive walk, or completing visiting a museum or visitor center exhibition), we are now doing our interpretive planning for the total experience package.

The total interpretive planning process must focus on the experience package a visitor receives from the total interpretive

or heritage tourism site, region or facility – not just on individual interpretive experiences. For example, walking down a beautiful trail and seeing wildlife and wildflowers is just as important an experience for the visitor as the actual interpretive experience the self-guided trail offers. Here are some things we now consider in our Experience Package for interpretive planning:

- *We need to theme the total experience.* We have known this for a long time in interpretive planning – developing interpretive themes for sites, but it now receives even more importance in the total site experience planning.

- *We need to try to harmonize impressions with positive cues.* In interpretive planning it is now even more important for the total site (restrooms, food service, and other support services) to support the theme in design and character.

- *We need to try to eliminate negative cues.* We do not want to take away from the theme or diminish the experience. That can range from litter pick-up to vista selection, to parking screening, and other design elements to keep the best face on the total site experience.

- *Mix in memorabilia.* This helps to extend the experience once the visitor has returned home. That adds greater importance on the design and stocking of gift shops, souvenir development (T-shirts, etc.), photo opportunities, and other memorable moment planning. For example, when I worked as a seasonal

interpreter at Ohio State Parks it was fun to watch a person touch a snake I was holding during a reptile program. This might have been their first encounter with reptiles and they loved having their picture taken holding or touching a snake. This memory for them was a product of the product for the reptile program – a memorable experience. So, we need to plan in more memorable opportunities for visitors during their total site visit.

· *Engage the five senses.* Plan for perceptually exciting areas for them to see and hands-on activities at interpretive stops or opportunities.

Experience realms: planning the mix of experience packages

Fig. 1 illustrates the main experience realms we can plan for and the psychology of the total experience(s). In general, visitors come to interpretive sites or attractions for one or more of these *kinds* of experiences. They are looking for *entertainment*, such as an evening campfire program; *educational* experiences such as attending an interpretive program on the historic or natural history of a site or area; *aesthetic* experiences, such as valuing the views, scenery, decorations, music or environment; and *escapist* experiences, such as wanting to go out on a wilderness experience, or seeing a movie to escape.

On the outer realm of the experiences are the various levels of experience participation. They can become *absorbed* in the experience, such watching a play, or losing track of time while they hike a trail or watch wildlife. They can

Figure 1: Mutually compatible experience domains often co-mingle to form unique personal encounters/experiences. (From Pine and Gilmore, 1999)

choose levels of *active participation*, such as going on a guided walk or tour, trying their hand at gold panning or fossil hunting. They can choose *passive participation* such as simply watching an interpretive activity or attending an interpretive demonstration. And they can chose to *immerse* themselves into the experience, becoming physically (or virtually) a part of the experience itself. This experience goes into the visitor as when playing a virtual reality game or computer activity in a museum or visitor center, or becoming a historical figure at a living history site.

Note that for most visitors it is not one or the other – many visitors will look for a *package of experiences* in the course of their visit – depending on the nature of your site. They may want to have fun and entertainment in the evening, take a class, watch the sunset, and escape the city walking a quite

wooded trail. We need to plan for all experience levels and opportunities.

Planning for the total experience begins at home

What the experience-based planning tells us is that we need to consider the visitors not just as a passive element at our interpretive sites, but the reason that most of our interpretive sites exist. We must plan not just interpretive media and services, but rather plan for a wide range of experience opportunities for visitors, from active and passive, to entertaining or quiet places of reflection. And the experience planning begins at home. This means that as we do our interpretive planning we need to consider:

- How visitors find out about us – our marketing and advertising media. Are our brochures or advertisements marketing things (trails, exhibits, etc.) or experiences and benefits the visitor will receive by visiting our site?
- Our experience planning continues with our directions as to how to find us, and the quality of the highway signage and way marking from the main highway exits to our parking lot (orientation systems). Getting lost trying to find an interpretive site or facility is *not* a good experience.
- The way staff members are trained to meet and greet visitors. This runs the gamut from the ticket takers, to the food service, to the interpretive staff.
- The visual cues of our site design and layout. Can

visitors easily find the places they want to see or use? Is there one themed look for the total site?

- The quality of the memory package we help visitors put together – (what will they talk about or remember the most on the trip back home?).
- The quality of the memorabilia we have available for them (souvenirs).
- And any number of other things that happen to them during their visit – all contributing to the total experience for each visitor.

So what's the state-of-the-art in interpretive planning?

In doing interpretive planning today, here is a summary of the key things that we now consider and plan for:

- Having a clear interpretive theme for the site or attraction.
- Having clear interpretive objectives for all interpretive services, media and programs, as well as for the total site experience (learn, feel, do).
- Having product-based objectives for our services and media (are we selling historic buildings – or having visitors value preserving historic buildings?).
- Having cost-effective interpretive services or media – so if we spend $$$ on interpretive programs, services or media, we get a real return for our initial investment.
- Planning for the total visitor experience, and planning for a variety of experience opportunities (all experience realms – or as many as possible).

- Planning for the memory package visitors take home.
- Planning for reasons for visitors to return to the site or attraction again (and again and again).

Summary

Try? There is no try. There is only do or not do – Yoda

Moving from *what if* to *what is*. The hardest part of being an interpretive planner is in knowing that what worked in planning yesterday may not work today. I believe that the key to today's successful interpretive and heritage tourism planning involves two steps.

Step #1 – Always keep learning how to do it better.

Step #2 – Implement the things you learned from step #1.

The most exciting thing about contemporary interpretive planning is not in what we know about effective interpretive planning today – but the things that we will know by next year! It just keeps getting better and more interesting.

For more information

Carter, James (Editor), 1997. *A Sense of Place – An interpretive planning handbook*. Tourism & Environment Initiative, Scotland.

The National Park Service, Parks and Recreation Technical Service Division (no date), *Marketing Parks and Recreation*, Venture Publishing, Inc.

Pine, Joseph B. and James H. Gilmore. 1999. *The Experience Economy*. Harvard Business School Press, Boston, MA.

Von Oech, Roger. 1989. *A Kick In The Seat Of the Pants*. Harper & Row Publishers, New York, NY.

Von Oech, Roger. 1990. *A Whack on the Side of the Head*. Warner Books, Inc. New York, NY.

Veverka, John A. 1992. *An objective look at interpretation*. John Veverka & Associates, MI.

11

Request for Proposal Guidelines And Template Resource Guide

The main tool used to find, evaluate, and eventually hire a consultant or supplier is a Request for Proposal or RFP for short. Oftentimes the success of having a relatively problem-free project is directly related to your RFP, and the selection criteria you used to select the ultimate winning proposal or bidder.

It is the goal of this resource guide to help you effectively plan and write an RFP to send out in your search for qualified bidders or consultants that will cover all of the key elements that should be contained in this important step towards your projects ultimate completion.

What is an RFP?

A request for proposal is just that. Once you have determined a specific project, such as the planning, design and fabrication of interpretive panels for example, and have been awarded a grant for that project, the next step is to find a firm that can plan, design, and fabricate those panels for you. But how do you find and select a company that can do that job? That's where the RFP comes in. Working from a bidders list of firms that can do that kind of work, you need to ask those firms to send you a proposal of just how they will do or approach that project, their professional qualifications and experience, and the costs. The RFP is what you send to those potential bidders. But for the potential contractors to give you a proper proposal and cost, they need to know exactly what it is you want done. Your RFP details the project needs for them to bid on, and the more specific the better. It also details the levels of experience

and qualifications you are looking for in a contractor as well.

Once a firm receives your RFP, and they review the qualification requirements of the bidder, the scope of work, budget, and other project needs, they will then send you a proposal to do the work the RFP asked for. But your RFP also needs to tell them how you want the proposal to be developed – what topics you want presented in what manner (photos, outlines, etc.), when you need the proposal, and other related issues.

If you haven't written RFPs before, it is easy to leave out some important topics or items that an RFP needs to have in it. It is the goal of this guide to help make sure that your RFP covers all the bases and works as an efficient tool to help you find and select the right consultant for firm for your project.

Contracting interpretive services: rules of thumb

Before you can write an RFP for an interpretive project, you need to know some basic information that will help your prepare the RFP, such as what various kinds of interpretive projects or media actually cost, what needs to be considered in the planning, design or fabrication of interpretive media, how long the project should actually take, and related issues. The following rules of thumb will help you in this area.

Rules of thumb for museum/visitor center exhibit projects

How much do exhibits actually cost? This is probably a question you should have asked before you asked for a grant, but if you didn't, here is the general rule of thumb for

budgeting/planning museum exhibit projects.

- Without having a specific interpretive exhibit plan detailing how many exhibits you need and their specific media components, the rule of thumb for budgeting exhibits is:
 - $400/sq.ft of floor space for the exhibit room or gallery. This is based on 2006 cost averages and can change depending on the kinds of exhibits you have. Interactive exhibits cost more, graphic and flatwork exhibits cost less. This figure gives you a fair mix of exhibits, from hands-on to non-interactive (flatwork panels).
 - Of this cost: 25% on average is the design fee.
 - 15% is for delivery and installation.
 - That means that if you have $1.00 to spend on exhibits, that $1.00 will buy $.60 worth of actual exhibit!
 - This cost estimate does *not* include high cost interactive media, such as touch-screens and the programs that would go with them. This would be an additional line item. The same is true for video and related high-tech equipment.
- How much space will I need for exhibits – and visitors.
 - One thing to remember about exhibits, and visitors, is that both need space. The exhibits need physical space, and the visitors need both physical and psychological space. If the exhibit room seems to crowded, even with great exhibits,

the visitors might not want to go in.

· The magic number to think about is that visitors need a *minimum* of 25 sq.ft of floor space per visitor in an exhibit room. That's a 5 foot box with the visitor in the middle of it. More space is ideal. Remember, if they feel too crowded, they will quickly move on and not enjoy the experience.

· Remember in planning space for exhibits to plan room for storage and access for replacing or repairing installed equipment. Also remember that the exhibit will take up more space than you think. Visitors usually view exhibits from several feet away from the exhibit. So there is a buffer zone of about 3 feet away from the exhibits where visitors don't stand. That buffer zone takes up physical space.

· Your RFP for exhibits will also need to consider the other requirement as general rules of thumb:

 · Are you going to need changing exhibits (that reflect seasonal changes or thematic changes)? For example, if your visitors are drawn form the same market year after year, then you will need to have exhibits that can change regularly. If, on the other hand, your visitors are tourists that you might never see again, your exhibits won't need to change as often. If you do plan for changing exhibits, such as seasonal changes, you may be buying 4 exhibits (one for each season) instead of

one exhibit, so those costs may be higher.
- Warranties and guarantees. You will need to be sure to ask for a warranty for your exhibits once they are installed. The typical museum exhibit warranty covers the exhibits for one year, and usually covers such things as items coming unglued from the exhibits, faulty audio-visual equipment, fading photos or graphics or other problems. It is good to check with other museums to see that kinds of warranties they have had from past projects, so you know what to ask for in your RFP.
- Time and more time. You should know about how much time to ask for museum or visitor center exhibit projects. In general for an average size visitor center, you should plan at least one year from the time the project starts to the day the exhibits are installed. Larger projects – more time. Usually there are 3 months for the planning and design phases, 5-6 months for construction, and a month for delivery and installation. Plus add a month or two for any problems that might come up. So a year is a safe bet. If it comes in earlier than that – celebrate.
- Plan in your time for reviewing draft designs. You will need to think about the time (and staff) you will need to review draft exhibit designs, and you will have to proof read and sign off on any exhibit

text (check for spelling, correct dates, etc.). It is a good idea to review exhibits at the contractors shop before they are delivered. That way and problems can be fixed in the shop.

· Plan for the installation. Remember that your exhibits will have to fit in your exhibit room or gallery. Make sure that they can fit in the door to your gallery and aren't higher than your ceiling.

· Maintenance Manual? As part of the RFP you should also ask for the contractor to provide you a maintenance manual. This includes information such as what kind of cleaning agents to use on your exhibits. They should also give you a list of suppliers where you can buy replacement parts (bulbs, electrical components, etc.) should you need to repair exhibits after the warranty expiries.

Rules of thumb for outdoor interpretive panel projects

Some of the same rules of thumb for planning for exhibit projects apply to planning outdoor panel projects, but there are some differences. There are lots of issues you will need to sort out *before* you write your RFP for Interpretive Panels.

How many panels do I want/need? You will need to determine just how many interpretive panels you need, where you want them to be located, and what size you want each panel to be. Location is an important consideration in determine just what materials and framing system your panels need to be fabricated from.

What are my options for panel materials? Which is best?
One of the main issues you will need to consider is just what kinds of materials you want the panels to be made of. Some of your choices include: fiberglass embedment, high pressure laminated panels, enamel or porcelain, plus a variety of other material options. You should probably get a list of outdoor panel companies, write or call each one and have them send you their brochure and samples.

Panel warranties. Many of the outdoor panel design and fabrication companies provide a one-year to 25 year warranty on their products. The warranty covers such issues as fading and de-lamination of panel materials. Look at the warranties or guarantees for each kind of panel material carefully to decide on which material is best for you and which to ask for in your RFP.

What are the average costs per panel that I should budget for?
In general, a 2' x 3' fiberglass interpretive panel (National Park Service Standard) will cost around $3000.00 per panel in 2006 costs. These costs include: Research/Design, Fabrication and shipping. Remember, if a company tells you that a panel is $800.00, that cost probably does *not* include design/graphics, shipping, and the frame or mounting system.

If you don't need an interpretive panel to last 25 years, (probably more expensive), then consider one that will last five years and cost less.

If you budget for the total cost per panel – final design, fabrication, shipping, and aluminum frame system, the total cost could be between $3000.00 and $4000.00 per panel. If

you have expensive artwork done, that cost could drive the total panel costs even higher. Of course this cost will vary greatly depending on the complexity of the design, the sign fabrication materials you select, the kind of warranty you want, and other variables.

How long should a panel project take? Panel projects should move more quickly than museum exhibit projects. Once you have determined the content of each panel, and have hired the consultants to do the design and fabrication, an average time from the time the project starts with the consultant, to the time the panels are delivered to you should be about three or four months, depending on the complexity of the project. Remember – this is an average rule of thumb.

Don't overload your pane – interpretive rules of thumb. Visitors will only spend about 15-20 seconds with your panel. Keep the text short (about 100 words). Use Tilden's Principals (provoke, relate and reveal your message). Keep the graphics or photos simple and powerful. Pre-test the draft panels with you visitors to make sure they understand the concepts and the vocabulary. Check about articles and other resources on planning and design of interpretive panels. Do your homework.

Rules of thumb for interpretive planning projects
The rules of thumb for interpretive planning project can vary a lot based on the particular kind of interpretive planning required. Here are some general guidelines.

What should be in (the contents) of an interpretive plan? This will vary from project to project, but in general you will need

to consider these issues before you write the scope of work for your RFP: What are the objectives that my interpretive plan needs to accomplish? How do I intend to use the final document (implementation of new products and services, for future grant requests, for other fund-raising programs, or other functions)? What services will I or my staff provide (maps, resource experts, etc.)?

What is the average cost of an interpretive plan? The costs of interpretive planning depends on the scope of services needed. Here are some general examples: Developing an interpretive master plan for a park, nature preserve, historic site, etc. between $6000.00 and $8000.00 (plus any consultant travel expenses). Developing an Interpretive Exhibit Plan – $6000.00 and up depending on the size of the exhibit room or gallery. Developing an Interpretive Self-guiding trail or tour route plan (for about a half-mile loop trail) – $4000.00 (includes developing 7-10 trail stops with draft copy). Developing an auto driving tour CD (production ready master), including all interpretive planning, writing, and sound studio work – about $1000.00/finished minute. These costs are subject to change based on specific project needs.

How long does it take to do an interpretive plan? On average, for most park or nature center interpretive plans, the time to complete the project is 3-4 months. Time frames for other types of interpretive planning will vary depending on the specific scope of work.

Qualifications of Interpretive Planners: Like other interpretive service providers for exhibits or outdoor panels, there are

qualifications for interpretive planners as well. Some of the qualifications you should consider include: Their training in interpretation (University Degree majoring in interpretation, professional agency training in interpretation, etc.). In other words, where did the learn how to do an interpretive plan. Years of experience in interpretive planning, usually a minimum of five years. Their approach to doing interpretive planning – what does their plan cover, etc. Their working relationship with you – how involved do you want to be in the project? Are they a National Association for Interpretation Certified Interpretive Planner? Plan time for an interview with bidders (in person or by phone). Ask for samples from past projects to look at (this should be in your RFP) if you feel that this will help you understand just what the finished plan will look like. Oftentimes products speak for themselves!

Request for proposal template examples
This section of the resource guide is designed to provide you with sample templates of different types of Interpretive Project request for proposals. The contents are taken from other good examples of RFPs and reflects the basic elements that any interpretive services RFP should contain.

Of course you can add any other sections to your RFP to reflect specific agency needs, standards or requirements.

Request for Proposal (Template)
Interpretive Exhibit Planning/Design and Fabrication Services
Agency or Organization Name
XYZ Visitor Center

Agency and project introduction
*This introductory section gives the bidder an overview of who you
are, what you do, and what the project is. It might give a brief history
of the project, who is funding it, and what you want the project to
accomplish when completed.*

Project requirements
*This section provides more detail on what you are looking for, such
as a team of experienced exhibit designers, or exhibit planners that
are familiar with a specific area's history. It may also describe other
project requirements such as the need for interactive exhibits, or
exhibit that are bilingual. Will the project require any handicap
visitor design needs or expertise?*

Scope of work
*This is one of the most important sections of the RFP. Here you will
detail exactly what the scope of work will cover. The following is a
template example of typical scope of work for an exhibit project.*

The selected contractor will:
Conduct a focus workshop session with staff to determine/
re-affirm, the main interpretive theme and sub-themes of the
total interpretive message presentation.

Develop, with staff, the specific objectives (in writing) – of the total presentation of the interpretive theme to include:

- Learning objectives
- Behavioral objectives
- Emotional objectives

Review the facility visitor numbers, market make-up and mix, and seasonal visitation patterns that might influence exhibit design, and any needs for easily changeable exhibits (seasonal or topical).

For each proposed exhibit, the exhibit designer will develop an Interpretive Exhibit Planning Form that details each individual exhibits:

- Main interpretive sub-theme or message concept.
- The specific recommended/approved objectives that individual exhibit is to accomplish (learn, feel, do).
- The best interpretive media or approach for that exhibit to accomplish its stated objectives.

The interpretive exhibit plan for the individual exhibits will be reviewed by facility staff and approved before moving on to the *design* phase of the exhibit project. The individual exhibits will be designed to accomplish the objectives stated, and draft designs will be reviewed for approval on how well the design addressed the specific objectives.

- Working with facility staff, review the facility collections for appropriate artifacts, photographs, or

related materials to help illustrate the theme of each exhibit.

- Provide a draft concept design for the individual exhibits, and the exhibit areas as a whole for review and approval.
- Develop draft label copy for the exhibits. Label copy should be interpretive and based on Tilden's *Interpretive Principles*.
- Provide a final design (based on comments from the review of the draft design) for approval.
- Provide exhibit fabrication as per your proposal.
- Have the client review exhibits at the production facility for any technical or editorial errors.
- Have the client – sign-off on the exhibits production after the on-site review.
- Install exhibits by the deadline set forth in the contract.

Additional considerations

- Contractor will provide a one-year warranty on exhibits.
- Contractor will provide a maintenance manual on exhibits (for cleaning, repairs, etc.).
- Contractor will provide a supplier contact list for any replacement parts that might be required in exhibit maintenance or operations.
- Contractor will provide the original manufactures warranty for any technical equipment if used (digital equipment, computers, etc.).

Agency provided services and materials

This is the section of the RFP where you list what products or services you will provide for the project. This might include:

As part of the project our agency [name] will provide the following materials or services for the project:

- Assistance in photographic research and photo selection.
- Assistance in historic or biological research.
- Assistance in artifact selection.
- Access to our historian or biologist (or other resource staff).
- Assistance in organizing meetings and providing meeting rooms and associated audio-visual needs.
- Current visitation data and records.
- Building blueprints.

Qualifications

This section is where you list the qualifications that the successful bidder or firm should possess. This might include:

Technical qualifications

Bidders should meet or exceed these minimum qualifications:

- Five or more years of experience planning, designing, construction of interpretive exhibits.
- It is recommended that the team has a professional interpreter on the team to provide the interpretive planning expertise.
- Have experience in planning/design of projects of a

similar size or nature.
- Have team members who have expertise in related subject matter.
- Have experience in designing interactive exhibits for children.

Bid submittal requirements

- Provide list/samples of interpretive exhibit design projects developed within the past year.
- Provide a sample of an interpretive exhibit plan illustrating how you developed the main interpretive theme and objectives for the exhibition.
- Provide a sample of your best interpretive exhibit design with a narrative of why the exhibit is interpretive (how did you use Tilden's Interpretive Principles in the design and message presentation?)
- Provide a list of three references from recent projects.
- Provide a list of personnel (resumes) who will be involved with the project management, interpretive planning, design, research and fabrication, including any/all sub-contractors.
- Provide a breakdown of budget:
- Exhibit research, planning and design
- Exhibit construction/fabrication
- Exhibit delivery and installation.
- Provide a draft project time line.
- Payment terms and conditions.

Selection criteria

This is the section where you explain how your will judge the proposals and the criteria you have established to make your final selection. This could include:

Selection criteria: Our selection criteria follow the rules and standards of [your agency or facility, such as a county government].

The selection of the successful candidate/bidder is not based solely on *low bid*, but on the best product to accomplish the objectives of the project. The successful bidder will:

- Meet or exceed the standards of [our] Program.
- Meet our city [agency or organization] standards for bidder qualifications through our formal bid process.
- Not exceed the amount budgeted for the project.
- Meets or exceeds the qualifications as listed in the RFP.
- Clearly details how they will accomplish the stated scope of work.

Interviews: The top three bidders will be invited (at their own expense) to do a formal presentation of their qualifications, examples of past projects, etc. to the selection committee.

Award of contract

Award of the contract is not based on low bid, but by the receipt of the proposal that best meets the needs of the [city, county, agencies, etc.], and this project.

It is our intent to select the consultant/firm no later than [date], and to have the project formally begin by [date].

Send one (or as many copies as you need) copy of your proposal to: [name and address you want the proposal sent to]. All proposals are due in our office by 5:00pm [date].

Any specific questions about this project or proposal contents should be directed to the project manager [name] at: [Address, phone, fax, e-mail].

Request for Proposal (Template)
Outdoor Interpretive Panel Planning/Design and Fabrication
Services
Agency or Organization Name
XYZ Visitor Center

Agency and project introduction

This introductory section gives the bidder an overview of who you are, what you do, and what the project is. It might give a brief history of the project, who is funding it, and what you want the project to accomplish when completed.

Project requirements

This section provides more detail on what you are looking for, such as a team of experienced panel designers, or panel planners that are familiar a specific area's history. It may also describe other project requirements such as the need for panels that are bilingual. Will the project require any handicap visitor design needs or expertise?

Scope of work

This is one of the most important sections of the RFP. Here you will detail exactly what the scope of work will cover. The following is a template example of typical scope of work for an exhibit project.

The selected contractor will:
Conduct a focus workshop session with staff to determine/ re-affirm, the main interpretive theme and sub-themes of the total interpretive message presentation.

Develop, with staff, the specific objectives (in writing) – of each interpretive panel:

- Learning objectives
- Behavioral objectives
- Emotional objectives

Review the facility visitor numbers, market make-up and mix, and seasonal visitation patterns that might influence exhibit design, and any needs for easily changeable panels (seasonal or topical).

For each proposed panel, the designer will develop an Interpretive Panel Planning Form that details that individual panel's:

- Main interpretive sub-theme or message concept.
- The specific recommended/approved objectives that individual exhibit is to accomplish (learn, feel, do).
- The best interpretive approach for that panel to accomplish its stated objectives.

The interpretive panel plan for the individual panels will be reviewed by facility staff and approved before moving on to the *design* phase of the exhibit project. The individual panels will be designed to accomplish the objectives stated, and draft designs will be reviewed for approval on how well the design addressed the specific objectives.

- Working with facility staff, review the facility collections for appropriate photographs, or related

materials to help illustrate the theme of each panel.

- Develop draft label copy for the panels. Label text should be interpretive and based on Tilden's *Interpretive Principles*.
- Provide a final design (based on comments from the review of the draft design) for approval.
- Provide panel fabrication as per your proposal.
- Have the client review panels for any technical or editorial errors.
- Have the client – sign-off on the panels production after the review.
- Ship panels by the deadline set forth in the contract.

Additional considerations:

- Contractor will provide a warranty on all panels.
- Panel specifications (list your panel material, size and thickness specifications here.
- Required panel mounting system (kind of panel frames you want) specifications) if you want the contractor to provide the frames too.

Agency provided services and materials

This is the section of the RFP where you list what products or services you will provide for the project. This might include: As part of the project our agency [name] will provide the following materials or services for the project:

- Assistance in photographic research and photo selection.

- Assistance in historic or biological research for text development.
- Assistance in organizing meetings and providing meeting rooms and associated audio-visual needs as needed.
- Other kinds of help you can provide for the project.

Qualifications

This section is where you list the qualifications that the successful bidder or firm should possess. This might include:

Technical qualifications

Bidders should meet or exceed these minimum qualifications:

- Five or more years of experience planning, designing, construction of outdoor interpretive panels.
- It is recommended that the contractor have a professional interpreter on the team to provide the interpretive planning expertise and interpretive text writing.
- Have experience in planning/design of projects of a similar size or nature.
- Be able to meet the design and fabrication specifications of the panels (panel materials, thickness, etc.)
- Be able to provide a warranty of the finished panels.

Bid submittal requirements

- Provide list/samples of interpretive panel design projects developed within the past year.

- Provide a sample of your best interpretive panel design with a narrative of why the panel is interpretive (how did you use Tilden's Interpretive Principles in the design and message presentation?).
- Provide a list of three references from recent projects.
- Provide a list of personnel (resumes) who will be involved with the project management, interpretive planning/writing, design, research and fabrication, including any/all sub-contractors.
- Provide a breakdown of budget:
- Panel research, planning and design
- Panel construction/fabrication
- Panel delivery and installation.
- Provide a draft project time line.
- Payment terms and conditions.

Selection criteria

This is the section where you explain how your will judge the proposals and the criteria you have established to make your final selection. This could include:

Selection Criteria: Our selection criteria follow the rules and standards of [our] Program.

The selection of the successful candidate/bidder is not based solely on low bid, but on the best product to accomplish the objectives of the project. The successful bidder will:

- Meet our city (agency or organization) standards for bidder qualifications through our formal bid process.

- Not exceed the amount budgeted for the project.
- Meets or exceeds the qualifications as listed in the RFP.
- Clearly details how they will accomplish the stated scope of work within the allotted time frame.

Award of Contract

Award of the contract is not based on low bid, but by the receipt of the proposal that best meets the needs of the [city, county, agencies, etc.] and this project.

It is our intent to select the consultant/firm no later than [date], and to have the project formally begin by [date].

Send one (or as many copies as you need) copy of your proposal to: [Name and address you want the proposal sent to].

All proposals are due in our office by 5:00pm [date].

Any specific questions about this project or proposal contents should be directed to the project manager (name) at: [Address, phone, fax, e-mail.]

Request for Proposal (Template)
Interpretive Master Planning Services
Agency or Organization Name
Project (White Lake Nature Center)

Agency and project introduction
This introductory section gives the bidder an overview of who you are, what you do, and what the project is. It might give a brief history of the project, who is funding it, and what you want the project to accomplish when completed.

Project requirements
This section provides more detail on what you are looking for, such experienced planners, planners that are familiar with a specific area's history. It may also describe other project requirements such as the need visitor analysis, resource analysis, or will the project require any handicap visitor design needs or expertise?

Scope of work
This is one of the most important sections of the RFP. Here you will detail exactly what the scope of work will cover. The following is a template example of typical scope of work for an interpretive master planning project.

The selected contractor will:
Conduct a focus workshop session with staff to determine/ re-affirm, the main interpretive theme and sub-themes of the total interpretive message presentation.

Develop, with staff, the specific objectives (in writing) – of each interpretive panel:
- Learning objectives
- Behavioral objectives
- Emotional objectives

Develop an interpretive master plan that addresses and contains the following elements. *The following outline is provided as an example and can be changed as needed.*

Introduction and scope of the plan
What was the scope of work the plan was to cover?

Main interpretive theme and sub-themes
(from focus workshops and site resource analysis):
- Main Interpretive theme and rational.
- Main Sub-themes and rational.
- Interpretive story-line flow bubble diagram.

Total interpretive program/services objectives (Learn, Feel, Do)
This is for the total interpretive program/services effort – site and/or visitor center combined. This usually comes from a focus workshop, and edited based on the interpretive site resources review.
- Learning objectives
- Behavioral objectives
- Emotional objectives

Visitor analysis

This is usually based on existing visitor data as doing new visitor surveys is both time consuming and expensive.

Sections of this part of the plan can include:

- Visitation numbers and trends over the past 3-5 years (graph this data).
- Basic market profile – who are the visitors, where are they travelling from, how long are they staying, gender and age variables, etc.
- Visitor experience desires or focus (why are they visiting this site?).
- Seasonal visitation trends or issues.
- School group and curriculum based interpretive planning needs and issues.
- Visitor management issues (relate to behavioral objectives).

Individual Site Interpretive Inventory and Story Development Forms

- Site resource location/inventory map. This map would show the locations of each interpretive site, feature, facility, etc. that an interpretive planning form set would be completed for (existing or proposed).
- Interpretive Site Index list. This is a list of all of the interpretive sites inventoried and included in the interpretive planning form sets that follow.
- Interpretive Planning form sets for each interpretive site inventoried including orientation sites, facilities,

trails, demonstration areas, historic sites, natural resource areas, etc. (existing or proposed).

For each planning form set include:

Site Inventory Form

- Site Index Number (keyed to map).
- Site Name
- Site Location (reference site index map, etc.)
- Site Description (refer to photos if available).
- Interpretive Significance (why are we interpreting this site?).

Story Development Form Set

- Main Interpretive Theme/Topic for each individual site.
- Site Objectives. These are physical development objectives such as building a stair way, add a viewing deck, etc.
- Interpretive program/services objectives. These are the specific objectives (learn, feel or do) that interpretive programs, services or media are to accomplish at this specific site.
- Recommended Interpretive Media for this location. This is a list of the interpretive media that could best be used to accomplish the stated objectives (i.e. self-guiding trail, interpretive panel, outdoor demonstration, guided walk, exhibit in a visitor center, etc.).

- Any budget issues or estimates. This helps make each individual interpretive planning form set a mini work plan for each individual site or feature that is part of the interpretive plan.

Five year implementation and operations strategy/matrix

This includes: Site Index Number – each Interpretive Media or Site Development needs – Fiscal Year for implementation – estimated cost for each site/item listed.

This allows us to plan priorities and costs for actually implementing the total interpretive plan 5 years down the road.

Evaluation recommendations

How will you know if the interpretive media you are going to purchase actually works (accomplishes its objectives), such as pre-testing interpretive panels in draft form, etc.

Appendices as needed

Agency provided services and materials

This is the section of the RFP where you list what products or services you will provide for the project. This might include:

As part of the project our agency [name] will provide the following materials or services for the project:

- Provide historical or biological research materials.
- Assistance in organizing meetings and providing meeting rooms and associated audio-visual needs as needed.

- Base maps of the site.

Qualifications

This section is where you list the qualifications that the successful bidder or firm should possess. This might include:

Technical qualifications

Bidders should meet or exceed these minimum qualifications:
- Five or more years of dedicated interpretive planning experience and/or
- have a university degree in interpretation or closely related field and/or
- agency provided interpretive planning courses or workshops (list) and/or
- be a National Association for Interpretation Certified Interpretive Planner and or other proof of specific qualifications in interpretive planning.

Bid submittal requirements

- Provide list/description of interpretive planning projects developed within the past year.
- Provide your qualifications in interpretive planning.
- Provide a list of three references from recent interpretive planning projects.
- Provide (resumes) of staff who will be involved with the project.
- Provide a sample of a recently completed interpretive plan similar in nature to this particular projects scope of work.

- Provide a narrative on how you will accomplish the stated scope of work.
- Provide a breakdown of budget for Master Planning Services and Travel expenses
- Provide a draft project time line.
- Payment terms and conditions.

Selection criteria

Our selection criteria follow the rules and standards of [our] Program.

The selection of the successful candidate/bidder is not based solely on low bid, but on the best product to accomplish the objectives of the project. The successful bidder will:

- Meet our city (agency or organization) standards for bidder qualifications through our formal bid process.
- Not exceed the amount budgeted for the project.
- Meets or exceeds the qualifications as listed in the RFP.
- Clearly details how they will accomplish the stated scope of work within the allotted time frame.

Award of contract

Award of the contract is not based on low bid, but by the receipt of the proposal that best meets the needs of the [city, county, agencies, etc.] and this project.

It is our intent to select the consultant/firm no later than [date], and to have the project formally begin by [date].

Send one (or as many copies as you need) copy of your proposal

to: [Name and address you want the proposal sent to].
All proposals are due in our office by 5:00pm [due date].

Any specific questions about this project or proposal contents should be directed to the project manager [name] at: [Address, phone, fax, e-mail.]

12

The Language of Live Interpretation: Making Contact

Interpreters must speak many languages! Not particularly foreign languages, but rather the language of the everyday person. Depending on the site or resource they are working with they may be called upon to speak:

- the language of children
- the language of rural visitors
- the language of urban visitors
- the language of experts
- the language of local residents
- the language of tourists, and more.

In interpretive terms, this means that they must relate to the everyday lives of everyday people. To help the interpreter do this there are a few general concepts and principles of recreational learning that may come in handy. This chapter will look at not only how to speak the conceptual language of the visitor, but how to make actual contact with your message or story.

Understand your visitors!

To be successful with live interpretation the interpreter should know as much about how visitors learn and remember information presented to them as they do about the resources or artifacts they are interpreting. It has been my experience that most museum interpreters are well trained in the materials of the museum or historic site, but receive little or no training in visitor communication strategies. Here are a few general learning concepts and principles that may be of use in preparing and delivering your live interpretive program.

Learning concepts

We all bring our pasts to the present. Try to find out what the knowledge or experience level of the visitors are related to your story or resource. Have they recently been to other museums or historic sites? If so, which ones? Did they have a good experience at those past visits?

First impressions are especially important. Make sure that the first impression the visitors have of you and your program are outstanding! This may be your greeting with the visitor at the start of the program, your appearance (are you in costume or uniform?) the visual look of the program starting point or other non-verbal cues.

Meanings are in people, not words. If I were to say the word *tree*, what tree would come to your mind? We all have our own visual dictionary and personal interpretation of words. When you describe an artifact or other resource in a lecture what does the visitors visualize? Make sure that you have the appropriate visual aides with you to avoid meaning differences between you and the visitor. Be aware too that most technical terms are new for visitors. Be sure to define them, don't take it for granted that the visitors know what they mean.

Simplicity and organization clarify messages. The chief aim of interpretation is provocation *not* instruction. During an interpretive program your job is not to make the visitor a expert in history, science, art, etc. Your job is to inspire them to want to learn more. Keep the program simple, focused, and fun.

Learning principles

Here are a few general learning principles that will help with the live interpretation program planning and presentation:

1. People learn better when they're actively involved in the learning process.
2. People learn better when they're using as many senses as appropriate.
3. People prefer to learn that which is of most value to them at the present.
4. That which people discover for themselves generates a special and vital excitement and satisfaction.
5. Learning requires activity on the part of the learner.
6. People learn best from hands-on experience.

With these concepts and principles in mind, you should also remember the following. Visitors remember: 10% of what they hear, 30% of what they read, 50% of what they see, 90% of what they do.

Planning for content

To help ensure success with the live interpretive program, it is helpful if the program is actually planned. Every interpretive program should be planned for success. This would include the following planning steps.

What? What is the main theme of the program. A theme is expressed in a complete sentence, such as "The logging history of Northern Minnesota still affects each of us here today". Another theme might be "The early settlers of the Rouge River

Valley found creative ways to farm the valley". The interpretive program then "illustrates the theme to the visitor".

Why? Why are you giving the program? What are your objectives for the live interpretation? The following are the three kinds of objectives that are needed for any interpretive program to be planned, with an example of each.

- Learning objectives. At the completion of the program 60% of the visitors will be able to describe three innovative farming tools invented by Rouge River Valley farmers.
- Behavioral objectives. At the completion of the program the majority of the visitors will want to look at the tools in the museum collection.
- Emotional objectives. By the completion of the program the curiosity and interest level in the visitors will be raised so that they will be motivated to want to look at the museum collections, and attend other live interpretive programs sometime in the future.

Remember, objectives are measurable. They are also tools to help you focus on just what you want your program to accomplish. As you consider the theme or topic for your live presentation, and have written the objectives you want the program to accomplish, there are two very important questions you must ask yourself about your program:

1. Why would a visitor want to know that? This is an important question for you to answer about the information you are planning to present. If you can't

think of several reasons why a visitor would want to learn the information in your program, you have a problem! This is where you relate to the visitor – give them a reason to attend the program.

2. How do you want the visitor to use the information you are interpreting to them? If you don't want them to use the information, then why are you doing the program? The answer to this question will become your behavioral objectives for your program.

You don't want to spend a lot of time giving answers to questions that no one is asking!

Who? Who are the visitors coming to the program? What is their age level, knowledge level, interest level, etc. How much time do they have? What do you think some of their objectives for attending your program might be? Any special needs of the visitors (visual or hearing problems, handicap visitors, etc.).

Considering the What?, Why?, and Who? parts of your live interpretation planning will help you focus you time and efforts. The answers to the two questions will help make sure the program is relevant to the visitor, not just the curators or resource experts.

The three B's
Interpreters are in the *benefit* business. Your interpretive program should be planned to illustrate to the visitors (and agency managers) three benefits. You should consider how the program will help:

- Benefit the site or resource. For example, will the program help reduce damage to historic structures, or help keep visitors on designated trails.
- Benefit the visitor. How will attending your program benefit the visitor? What's in it for them? The answer to this question is what you use to advertise the program.
- How will your program benefit the agency you work for? More memberships? More gift shop sales? Better political image?

What is the product of your product?

In doing live interpretation it is easy to get caught up in the interpretation and forget what our real product is. By selling *the product of the product* you put the idea of your program in a context that the potential user knows and understands (relates to). For example, in the commercial world:

- Are you selling drills, or holes?
- Are you selling cosmetics, or hope?
- Are you selling new cars, or status?

What is the product of the product for your live interpretation?

- Are you selling looking at artifacts or valuing the cultures/people that made them?
- Are you selling looking at rooms of furniture or pride in the people that made and used the furniture.
- Are you selling collections, or the benefits to all people in the saving and conservation of historic materials?

To make contact…

We know from years of interpretive research that the live interpreter is the most powerful of all of our interpretive media and opportunities. The interpreter can instantly read an audience, make adjustments in the program to help relate to the different audiences they may encounter. They can look into the eyes of a visitor and grab the visitors imagination and emotions. They can take a boring topic and make it come to life for the visitors. But to be successful, live interpretation requires that the interpreter think about and plan for their success. Being successful with any live interpretive programs requires the interpreter to identify what they mean by success. The successful interpreter will need to understand how their visitors learn and remember information and how to provoke, relate and reveal the story to them. They will have a focused message (theme) and objectives that they are going to strive to accomplish. They never stop trying to improve their program and trying new ways of inspiring the visitors. The reward the interpreter receives from his or her work really cannot be put into words – a deep sense of satisfaction, pride, and more. The reward the visitor receives from the interpreters efforts are equally as powerful. For when a trained, focused, and inspirational interpreter meets with visitors hungry for inspiration, something special happens. They make contact and the journey begins.

References

Ham, Sam H. (1992) *Environmental Interpretation – A practical Guide for People with Big Ideas and Small Budgets*. North American Press, Golden, CO.

Lewis, William J. (1988) *Interpreting for Park Visitors*. Eastern Acorn Press.

Tilden, Freeman (1957). *Interpreting Our Heritage*. The University of North Carolina Press, Chapel Hill.

13

Using Interpretive Themes and Objectives Will Make Your Program Planning Easier and More Effective

Perhaps two of the areas where there is often the most confusion in planning for interpretive programs or services is that of developing interpretive themes and interpretive program or services objectives. Here are a few ideas and examples that may help making this part of the interpretive planning process easier and more effective.

What is an interpretive theme? A theme is the central or key idea of any presentation. When communicating with your visitors, the audience should be able to summarize the main point of the program in one sentence. This sentence would be the theme. Development of a theme provides organizational structure and clarity of purpose of the program. Once the main interpretive or story line message theme has been decided, everything you do in presenting the program or service to the audience falls into place. The main strategy then of the interpretive program is to illustrate the theme statement.

Themes should:

- Be stated as a short, simple, complete sentence.
- Contain one main idea if possible.
- Reveal the overall purpose of the program or activity.
- Be interestingly and motivationally worded when possible.

Here are some examples of themes:

- Exploring caves is a sensual experience.
- We manage our habitats to benefit both people and wildlife.
- Backyard wildlife needs your help.

- Our forest has many plants that heal.
- Living in the Smith homestead was full of daily challenges.
- We need to preserve wetlands for five reasons.
- Steam engines changed our lives in three ways.

It is important not to confuse themes with topics. Examples of topics that might be mistaken for themes might be:
- Birds of the Park.
- Seasonal Wildflowers
- Bird migration.
- Cooking with native plants.

Be sure your themes are complete sentences – and meet the other criteria noted above.

Interpretive objectives

Many interpretive programs or services are planned without objectives or real outcomes. I find it hard to successfully plan any interpretive program, service or media without clearly understanding just what it is the interpretation is supposed to accomplish.

Objectives vs. goals

There is often some confusion between the two. I usually don't use goals, as goals aren't measurable, like "it is my goal to go to Florida some day".

Objectives are outcome driven and measurable. For

example if we had the interpretive theme: "Wetlands benefit us in amazing ways," then we need to develop interpretive objectives that would help illustrate that theme, such as: "At the completion of this program all participants can identify three ways that wetlands benefit us."

This objective statement can be pre-tested with visitors to see if they already know or can name three benefits, and then post-tested after the program to see if they can name three benefits. If they can't – the program didn't accomplish its objectives. You can't really evaluate the success of any interpretive program or service without first understanding what the outcomes – objectives – of the program or service were.

I use three kinds of objectives in interpretive program/ service planning:

Learning objectives: The majority of visitors will be able to (name, list, describe) three reasons that wetlands should be protected.

Emotional objectives: The majority of visitors will *feel* good about the preservation work we are doing here to protect wetlands. The majority of visitors will feel that protecting wetlands does indeed benefit them, their community and the environment.

Behavioral objectives: The majority of visitors will want to see the wetland exhibits in the Nature Center. The majority of visitors will consider contributing to our *Preserve the Wetlands* fund. The majority of visitors will want to walk our wetlands trail looking for the wetland features from the program.

These *Learn – Feel – Do* objectives are central to interpretive program planning – particularly the Feel and Do objectives. You can have as few or as many objectives as you want. They are your guidepost to what is really important for the program to accomplish and how you want the program to affect your visitors. Two hints in making sure your objectives are marketable (people will want to come to the program). Ask yourself:

1. Why would my visitors want to know this information?
2. How do I want my visitors to *use* this information (from the program)?

The answers to these questions may help guide your objective (program content and proposed outcomes) development.

Summary

With your theme in hand, and your objectives in place, you are now ready to develop the various teaching aids, demonstrations, visual presentations, and program presentations to illustrate your theme, and then evaluate the effectiveness of your program.

Remember that the theme is the one thing that – by gosh if nothing else – the visitor remembers from the interpretive program or service. You begin the program by stating the theme – and then summarize the program at the end by again stating the theme "... so now we have seen three examples of how protecting wetlands benefits you".

The objectives will focus the content of the program, help

you plan the total presentation, and will be used to evaluate the program to see if it was really successful - or just entertaining.

Now you know, and can hopefully describe why: Using interpretive themes and objectives will make your program planning easier and more effective.

References

Ham, Sam H. 1992, *Environmental Interpretation*. North American Press.

Lewis, William J. 1988. *Interpretive for Park Visitors*. Eastern Acorn Press.

14

Why Heritage Sites Need Interpretation For Their Long-Term Survival

So why do heritage sites need interpretation to survive?

In some cases where a heritage site is big enough or well known enough, it might not require as much interpretive effort to attract visitors – people will want to see it or experience it because of other benefits the site provides. Interpretation is a value-added benefit to the total site visit.

But for most moderate to small heritage sites, providing outstanding interpretive programs and services, and having a good interpretive plan will be required for their long-term tourism success.

Definitions

Before we look at the reasons heritage sites need interpretation, we should have some definitions to work from.

Heritage tourism: Visitors travelling to see, experience and learn about (edutainment) natural or cultural landscapes, sites, features, objects, people, events and stories. It needs to be noted here that the educational component of this type of tourism is the key aspect of it. Visitors want to learn, see, and do! They travel to heritage sites for a mix of edutainment experiences.

Interpretation: A communication process designed to reveal meanings and relationships of our cultural and natural heritage to visitors, through first-hand experiences with objects, artifacts, landscapes, and sites.

Without interpretive services – having trained and skilled interpretive staff present the unique story of each heritage site to visitors, or develop and offer outstanding self-guiding

interpretive opportunities for visitors – you don't have a historic or heritage site – you have an old site. It is in the interpretation of the sites story to visitors where the heritage of the site is brought to light. Interpretation makes the site come to life for the visitors, giving the site relevance and importance. It reveals to visitors, in powerful and memorable ways, the differences between old and historic.

Interpretation is the most powerful communication process any historic or heritage site has available to communicate its message(s) to visitors!

This may sound like a strong statement, but it's true. This is because of where interpretive communications strategies have come from: marketing, advertising, psychology of the audience, recreational learning theory, consumer behavior and other related professions and disciplines. Every time you see an advertisement on television or see one in a magazine, you are seeing the principles of interpretive communication at work. Here are just a few of the elements interpretation and professional interpreters bring to heritage sites.

Knowledge and expertise in:

- Journalism (exhibit label copy, brochures and site guides, news releases, etc.).
- Market analysis and evaluation.
- Market creation and tourism planning.
- Market diversification analysis and development.
- Willingness to pay analysis and understanding.
- Critical mass for regional tourism development and sustainability.

- Psychology of the audience.
- Psychology of the visit.
- Persuasion strategy development for interpreting critical management issues.
- Perception of the experience (experience marketing).
- Non-formal or recreational learning theory and recreational learning program development (learning for fun or enjoyment).
- Site interpretive master planning skills.
- Interpretive program, services and media development.

So which of the things on the above list can a heritage site do without having – and be truly successful in reaching its full heritage tourism potential? *None*. From this list, there are required elements that interpretation brings to the total heritage site success equation, no matter how heritage sites define *success*. Here are three ways that interpretation fits into success equations.

Financial success
For every heritage site, the first rule of business is to stay in business. This means that the heritage site has to be financially successful. So the financial success equation might look something like:

overhead and operations costs – visitor admission fees and related sales + outside funding = a positive number.

Success can be a break-even goal, or a goal to make a profit to enable the site to do repairs, add staffing, do restoration

work, etc. Interpretation brings in visitors and $$.

A second type of success equation – political and community support success – might look like:

quality interpretation presentation + quality of site experiences + real or perceived benefits of the site/agency to visitors and the community + evidence of value and benefits.

For this success to occur the site must be using quality interpretive communications to maximize the visitors and community perception and value of the site – and support the site mission. It is difficult to accomplish this type of success to its fullest potential without active and powerful site-based interpretation (programs and services) and exploiting interpretation's powerful public relations potential.

A third type of success is measured by the level at which the historic site mission and objectives are accomplished:

(cost of interpretive programs/services ÷ number of visitors that receive the message) + the % rate at which the objectives were accomplished = benefits greater than the cost of the contact (yes or no).

In other words, if you spent $100 on an interpretive board, and 100 visitors saw and read the message, then the cost per contact would be $1.00. The questions is what happened as a result of that contact? If you spent $1.00 per contact and, as a result, had a management objective accomplished at a 70% level – let's say a reduction in littering or less complaints about a management activity – then a reasonable cost per contact for a high cost-effectiveness ratio (getting a real return for your interpretive investment) = success.

In this example as well, professional interpretive planning and design is key to the successful cost-effectiveness of the interpretive media or services presentation. The media must effectively motivate, stimulate, inspire, and touch visitors for them to react to the message.

So no matter which type of *success* you are interested in, one or probably all, you cannot ever reach your true success potential in heritage tourism for your site without using quality, professional interpretation (programs, services, media and staff) to effectively communicate to your various target market groups.

Why is interpretive communication so powerful?

The main principles of communication used in developing any ad campaign are a foundation of interpretive communications. Professional interpreters use their understanding of interpretive techniques to develop the interpretive program, service or media to:

- Provoke the attention of the visitor.
- Relate to the everyday lives of visitors.
- Reveal the essence of the message in a unique or interesting manner.
- Develop objective and outcome-based media, program or services plans.
- Target messages to specific market groups interests, backgrounds and feelings.
- Have in-depth understandings of their audiences.
- Can make the presentations fun, inspirational,

memorable and powerful.
- Plan for the total visitor experience.
- Plan for low cost per contact while getting high cost-effectiveness from the communication (media, programs or services).

What benefits does interpretation bring to historic site management? Success!

- Interpretation shows the visitors why the heritage site has value – to them (the visitor), to the community, and perhaps regionally or nationally.
- Interpretation can inspire visitors and create a sense of individual and community pride.
- It is the interpretation (programs, living history, guided tours, exhibits, etc.) that visitors come to the heritage site for – the story and site experience. Without interpretation a historic site is, in the eyes of the visitor, just another old site.
- Interpretation gets visitors to care about heritage (theirs or other cultures).
- Interpretive services are the reasons visitors come back to heritage sites.
- Interpretive programs and services can increase visitation by increasing the perception of benefits tourists receive by going to a particular heritage site.
- Interpretive programs and services can produce reductions in site maintenance, and related management issues when used as a management tool.

- Interpretive programs and services can make money!
- Interpretive programs and services provide added value to any heritage tourism experience, and heritage site marketing efforts.
- You cannot have heritage tourism without interpretation. Heritage tourism is dependent upon the story of the site and the willingness of visitors to want to travel to see, learn about and experience the site.
- Interpretation brings in more visitors, more repeat visitors and more income.
- Interpretation helps visitors create their own unique choice of ways to experience and learn about a site and its story (mass customization and markets of one).

How do you know when heritage sites need interpretation – warning signs

Here are a few indicators that heritage sites are in need of interpretive programs or services (new or improved):

- Visitation numbers have not significantly increased over the past 2-3 years (and you can't always blame it on the weather).
- Visitation numbers have flat lined (no growth).
- Visitation numbers are far below expected numbers in relationship to site location (population bases), and visitation numbers to other similar heritage sites.
- Visitation numbers are decreasing (over one or more years).

- Site visitor management problems are increasing or remain unresolved (littering, etc.).
- You have very poor community support (image, etc.).
- You are experiencing a reduction in grant aid support from past years.
- Visitors do not leave your heritage site truly understanding the story of the site, or the value in preservation of historic sites and landscapes.
- Memberships to your organization are flat or declining.
- Your agency has poor name (and mission) recognition.
- Your heritage site lacks sparkle, excitement, fun, experiences, and BENEFITS to visitors. Your marketing brochures have pictures of landscapes, furniture or buildings, but no people in the pictures.
- You have to reduce hours of operation due to poor visitation.
- It is difficult to keep guides or volunteers.
- Staff begin to move on to other sites.
- On a Saturday afternoon in the summer your site looks empty.

Interpretation is an attitude

Interpretation is not just a thing, like a board or exhibit. It is a way of thinking about the quality of the communication and services you will provide to visitors. It is the desire to make sure that the presentation of the heritage site message or story is cost-effective, powerful, and gets results (outcome-based objectives). It is a love of talking to and with visitors,

and getting them as excited about the site as you are. It is a commitment to providing uncompromising quality for the visitor's experience, and always leaving them asking for more! Without this attitude about interpretive quality and customer care excellence, the site and visit becomes stale, boring and lacks soul. The result – visitors can sense this and register their feelings by not coming back again. Heritage sites need interpretation to help attract visitors – with out interpretation, heritage sites are empty shells of lost opportunities.

Summary

Interpretation is an indispensable part of a heritage sites ultimate success (financial, political and educational). Interpretation of the site story and message is the main reason visitors go to heritage sites, and a key element in any heritage tourism site development. Heritage sites can never truly reach their success potential without having interpretive plans, programs, services, media, and staff to relate the site stories and importance to visitors. Interpretive programs and services can help increase site visitation, increase repeat visitation, increase and improve community support, and a variety of other benefits to the heritage site(s) using this powerful communication strategy.

References

Gilmore, James. H. and B. Joseph Pine III. Markets of One. *Harvard Business Review*, 1988.

O'Sullivan, Ellen and Kathy Spangler. *Experience Marketing: Strategies for the New Millennium*. Venture Publishing, 2000.

Pine II, Joseph B. *Mass Customization*. Harvard Business School Press 1993.

Pine II, Joseph B. *The Experience Economy*. Harvard Business School Press, 1999.

Schmitt, Bernd. H. *Experiential Marketing*. The Free Press, 1999.

Tilden, Freeman. *Interpreting Our Heritage*. The University of North Carolina Press, 1957.

15

Why Your Scenic Byway Can't Succeed
Without Real Interpretation

A Scenic Byway without interpretation is just another pretty road!

At first it may sound dramatic that the success of a scenic byway depends on the amount of and quality of heritage interpretation associated with it. But the statement is in fact true!

To byway users, especially those who have driven the route before it was designated a scenic byway, it's just a road to get to and from someplace. For potential heritage tourists, it just might be a scenic route – but they will see lots of those on their trips. So what makes this scenic byway so special? That's the job and role of the byway interpretive plan, and byway interpretive media and services. It is the interpretive communications strategy that will help each visitor understand the unique and special stories associated with each unique byway. Interpretation reveals the story of the people, places and events that have occurred, or are occurring along the byway, and help guide visitors through a living museum of regional natural and cultural heritage. It changes the byway from being a place to being an edutainment experience. It gives the byway a totally unique character, personality and life. Without interpretation, it's just a road!

What is interpretation?

While you may have heard of interpretation and the need for it to be an essential part of the total byway planning and experience, you may not know exactly what interpretation, and interpretive communications is.

Interpretation is defined as: "a communication process

designed to reveal meanings and relationships of our cultural and natural heritage to the public, through first hand experiences with objects, artifacts, landscapes, or sites".

Information vs interpretation

Most byway interpretation is not really interpretive! It is just information. Lots of facts, figures, pictures, dates, or other data arranged and presented to visitors via signage, brochures, CDs, or other media given to visitors. In many cases it presents answers to questions that visitors are not asking!

Interpretive communication takes the information – transforms and translates the information into the language of the visitor. To be truly interpretive, the message (interpretive panel, brochure, etc.) must follow the following criteria:

- The communication must first *provoke* the attention or curiosity of the audience.
- *Relate* to the everyday life of the visitor – tell them why they need to know this information.
- *Reveal* the key concepts of the message or story through a unique viewpoint – save the surprise ending or answer for last.
- *Address the whole* – illustrate to the visitor how each individual stop along the byway relates to the larger main interpretive theme or educational concept of the total byway experience or story.
- *Have message unity* – the design and presentation of the interpretive media along the byway will have a uniform themed look (design, fonts, historic dating, etc.).

Interpretive planning for scenic byways: basic considerations
In developing an interpretive plan for any scenic byway, the following areas are essential to the successful communication of the byway story to the visitors.

Conduct an interpretive story inventory along the total byway (historic sites, industrial sites, natural sites and features, historic events, current sites/events of interest, view sheds, perceptually exciting areas (visitor perceptual psychology), etc.

Develop a main interpretive theme, sub-theme and story line for the byway. This might include developing a variety of themed self-guiding tours based on visitor interests such as: railroad heritage stops, historic landscapes, geology tours, industrial heritage tours, watchable wildlife tours, natural history from the car window tour stops, etc.

Develop very specific learning, behavioral, and emotional objectives that the total scenic byway tourism/education experience is to accomplish. Then develop specific interpretive objectives for each individual byway stop.

Audience or market analysis – who are the current or potential byway users or potential tourists, what kinds of heritage topics would they most be interested in, what are their travel destinations, why would they want to drive this byway. In any heritage tourism marketing you only market one thing Benefits. What are the specific benefits that a byway visitor would get from driving the byway?

Determine the most cost-effective interpretive media for the byway: Interpretive Panels (number, size, locations); self-

guiding booklets; self-guiding CDs, step-on guides for tour buses, etc.

Develop an implementation strategy for the byway interpretation. This would include costs of media, development and installation times, maintenance or distribution considerations, etc.

Evaluation – it is important to pre-test any/all interpretive media (panels, self-guiding booklets, etc.) to make sure that the interpretive objectives are met, and that the visitors can easily understand, relate to, and remember the information being presented to them by the media in question.

You see or hear interpretive communications in use everyday! It is important to remember where interpretation and interpretive communication has its roots. Interpretation communications techniques, principals, and practices come from the following professions and academic subject areas:

- Marketing
- Advertising
- Consumer behavior
- Psychology of the audience
- Non-formal learning theories
- Recreation planning and/or historic site planning
- And more!

Based on the above, essentially every advertisement you see or hear is based on interpretive principles. Ads must *provoke*, *relate*, and *reveal* to the potential user: why they need this

product or experience, how the product or experience will benefit them, and how easy to obtain or inexpensive the product is in relationship to its benefits. These are the same principals we use in developing interpretive plans and media. This is how we market the byway experience.

Ten reasons your byway needs interpretation to be successful

Of course, this depends on how you define success. I define success based, in part, on how well the educational and tourism development objectives are accomplished. Here are my ten reasons, not in any particular order of importance you need interpretation:

1. Regional residents/byway users will gain a greater appreciation and pride in their own local heritage.

2. Regional residents may be inspired to take a more active role in the stewardship of local natural and heritage sites and features.

3. Regional residents may take on a individual pride in the byway resource (have a sense of community ownership in the byway).

4. The byway interpretation serves as a heritage tourism draw or enhancement to bring other visitors to the communities, sites or attractions located along the byway. This may have direct positive economic impact to these communities or heritage sites.

5. Visitors will use the byway in a safer and more responsible manner.

6. Visitors will have a positive educational as well as

recreational experience, learning more about the natural and cultural history of the region(s) they are passing through.

7. The byway interpretation of local natural or cultural history may inspire visitors to visit other nearby heritage sites – helping regional heritage tourism grow.

8. Byway interpretation can increase repeat use of the route for recreation/scenic driving.

9. Having a variety of interpretive themes and topics of interest can increase the marketability or use of the byway by more diverse target market groups.

10. Interpretation can present information at a variety of experience and educational levels, helping to expand the marketability of the byway and its associated attractions.

These are a few of the desired outcomes for a successful scenic byway interpretive program or plan. These outcomes will not happen without interpretation! So as Paul Harvey would say now you know the rest of the story as to why you need interpretation to have a truly successful scenic byway.

References

Veverka, John A. *Interpretive Communications – The Key to Successful Heritage Tourism Marketing, Planning and Program Design*, 1998. Occasional paper presented at a number of interpretation and heritage tourism conferences in the US, Wales, England, and Scotland.

16

Interpretive Program
Planning Worksheet

Program title

Interpretive program theme
(*A theme is a complete sentence that states the main idea or concept that this program will illustrate. This theme is stated at the start of the program, repeated throughout the program, and then used to summarize the program at the end. An example of a theme might be: Preserving wetlands benefits both people and the environment in three ways. The program would then provide examples of the three ways.*).

Interpretive program objectives
(*Objectives are the measurable outcomes that you want this program to accomplish, and are the basis for your program evaluation. An example of a learning objective might be: Upon completion of this program the majority of visitors can state at least two ways preserving wetlands benefits people.*)

Upon completion of my program I want the majority of visitors to:

Who is your audience, what teaching aides or other support examples will you need to help them better relate to and understand your interpretive program and theme?

How/When/Where will you present/conduct this program?
How: Live demonstration ___Guided tour ___ Lecture ____
 Other media/service: _____
When: Program date/time: _____
Where: Program location: _____

Implementation
(What will you need to present this program such as teaching aides, handouts, live animals, CD of bird songs, etc.?)

Self-evaluation
(How will you determine if the objectives of your program were accomplished?)

Post-program comments

(What part of the program worked best, what would you do differently, was the program length to long, was the program schedule OK, too early, or too late, etc.?)

17

Interpretive Tips Practicum

By now you have seen several examples of doing interpretation. The steps again are to:

1. Start off with a provocative statement.
2. Relate to your audience by using analogies, metaphors, etc. to help then understand your concept or message in people terms.
3. Reveal the answer through a unique or surprising viewpoint. Are we guessing what the answer might be?

Here is your task! You are going to interpret some object to us – in a one or two minute presentation.

Look around your table/seating area and pick some object you can interpret to us. It might be a cell phone, glass of water, piece of paper, candy, or any other object you would like to use. What object did you select? _____

You picked something – good. Are you ready for the next step? Think of some way to *provoke* us with an opening statement like – "I am holding the very first computer" (a pencil). Or "Did you know this object can save you life?" (Cellphone?). You might want to keep the object hidden and have us guess what it is. What is your *provocative* opening statement?

Now how will you *relate* the message to us? (Why do we need to know this information?). Will you use analogies (as big as a...)? Or other ways to relate (food, sex, family, etc.). What are some ways you can relate the message to us so that we will understand it better? _____

Reveal – the fun part. This is where you will *tell us the answer* (how this plant can save your life, or how the pencil is the first computer, etc.). My revealing statement is: _____

Address the whole: What was the main point you were illustrating, the main interpretive theme? Be sure to summarize the main point.

Strive for message unity: Did your illustrations, voice, selection of words all work together to help illustrate your main point?

Next time you look at a newspaper, look for the provokes in the headline, and how they relate and reveal the essence of the story. These principles are the basics of advertising. You will also see provoke, relate, reveal in the way advertisements are presented on TV. Look for them – they are there along with addressing the whole and message.

PLANNING

18

Interpretive Master Planning Keeps Your Garden Growing

It's not just botanical gardens that need the care and feeding provided by Interpretive Master Plans – but all heritage attractions do. From parks and zoos to other heritage areas – they all need interpretive master planning to keep them growing. Of course, by growing I mean that they can create interpretive programs, services and media that are, first, actually interpretive instead of just informational; second, effectively communicate their main messages to visitors in a format that visitors understand and relate to; and third, help accomplish the main mission and goals of the agencies involved. Thus interpretation keeps your garden growing in visitation numbers, support by visitors and increase in memberships, and by physical growth of interpretive programs, services and outreach activities. The Benefits of the interpretive plan are great as well. It helps you focus the short and long term accomplishment of your mission, helps you make long term cost-effective interpretive program and media decisions, helps develop your marketing strategy, and more. Interpretation brings in more visitors. The interpretive plan tells you how to do it.

So why do you need interpretive planning?
First of all, you must understand that interpretive communication is the most powerful communication process you have available to you to communicate to your visitors with. All of the principles of interpretation come from marketing and advertising. So when you see a powerful advertisement on the television, or in print media, they are using interpretive

Figure 1: The ear provides an opportunity to interpret ground water. Children can listen to water dripping and moving through underground pipes.

communications. You can't communicate to your visitors successfully without it!

What is real interpretation anyway?

Interpretation to some is a word like ecology. We hear the word but most of us have never actually seen one because it is a process of interrelationships more than a thing. Interpretation is like that in that you may have never actually seen any media or exhibits that were really interpretive! Does that provoke you? First let's take a look at the definition of interpretation – yes there really is one:

> *Interpretation is a communication process designed to reveal*
> *meanings and relationships of our natural and cultural herit-*

*age to visitors through first-hand involvement with objects,
artifacts, landscapes, build features, experiences and sites.*

To be interpretive the communication process must follow
or be based on Tilden's Interpretive Principles. That is, the
interpretive communication process must:

- Provoke attention, curiosity or interest in the visitor.
- Relate to the everyday lives of the visitors. (Why would
 a visitor want to know this?)
- Reveal the main essence of the story message in a
 memorable way (the *Oh My* effect).
- Address the whole – that is work to illustrate a common
 theme, message or big picture concept for the visitor –
 the one main idea you want them to take away.
- Strive for message unity – use the right supporting/
 design materials (sounds, colors, materials, graphics,
 etc. that thematically support the message).

So when we develop an Interpretive Master Plan, the job of that
interpretive plan is to insure that these interpretive techniques
and principles are used throughout the total site interpretive
presentation – trails, outdoor displays, live programs, visitor
center exhibits and other related media.

Figs. 1 and 2 are examples of interpretive exhibits from the
Frederick Meijer Gardens in Grand Rapids Michigan. These are
in their children's garden. Each of these exhibit areas with their
activities provokes your attention, relates to the everyday lives
of the visitor, and has a revelation to its message. In this case

Figure 2: in this hands-on exhibit, each finger of the hand has a different texture that relates to the different textures of the leaves on the plants within the display. It works great in summer when the plants are all out.

all the exhibits relate to the senses children can use in enjoying and exploring the garden.

What is an Interpretive Master Plan?

Imagine your garden as a 500 piece puzzle. What visitors see as they move through the grounds may very well be these puzzle pieces in random order, not receiving a clear message of who you are, what you do, and why you do it (your mission). What an interpretive plan does is provide the picture on the cover of the puzzle box for both the visitors and for you. It helps you organize your main messages for visitors so they can clearly understand them throughout their visit, and your strategy to

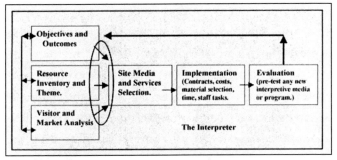

Figure 3: Managerial realities

create and deliver those messages through media and services at key interpretive sites and areas.

The parts of an Interpretive Master Plan

It is probably easiest to look at the Interpretive Planning process in the form of a model (Fig. 3). We can think of the interpretive planning process in sections.

First you see the large box in the model called managerial realities. These are issues that you might have problems with: budget, available staffing, political support, time, existing policies or directives, mission, etc. We identify these at the start of the interpretive planning process so we can do the plan with these constraints in mind.

Then find the big box that all the parts reside in called The Interpreter. That's you if you're the interpretive planner, or your planning team. There's always more than one right answer, and each interpreter or team brings their own unique values, ideas, creativity and knowledge to the project. Within this big box is the process, which I have divided into sections or tasks:

Section I – includes three components

First, for the interpretive plan we must clearly identify, write, or create the specific objectives that we want interpretation to accomplish for the total Botanical Garden experience for visitors. These include learning, behavioral and emotional objectives. Here are some examples of these kinds of objectives.

Learning objective: upon completion of reading the interpretive panel the majority of visitors will be able to identify three key components of a plant's reproductive strategy.

Emotional objective: upon completion of their visit to the Botanical Garden the majority of visitors will value and appreciate their native plants in a new and more powerful way.

Behavioral objective: upon completion of their visit to the Botanical Garden 10% of the visitors will want to consider landscaping their home gardens with native plants.

Second, we conduct a complete inventory of all interpretive sites and resources where we want to have some interpretation take place. From this inventory of interpretive sites and features we then develop our main interpretive theme, sub-theme and story line that we want to present and illustrate to visitors. In general we may inventory:

- G – Geological sites and Features
- B – Botanical Habitats
- BD – Botanical Demonstration Areas.
- SBD – Seasonal Botanical Demonstration Areas.
- F – Facilities (Interpretive Centers, Gift shops, etc.).
- H – Historical sites, facilities or features.

- R- Research sites, demonstrations or programs.

I generally give each category a code (G = Geological, etc.) as a way of grouping interpretive resources. These codes will appear on our standard interpretive planning forms to help identify each unique interpretive site or feature within the property. So if we have seven different biological habitats within the garden, each will be coded as: B-1, B-2, B-3 and so on.

Third, we also need to know as much about our visitors as possible. Who they are, where they come from, age groups and related demographics, seasonal visitation patterns, and their main motivations for the Garden visit. What do *they* want to know, learn, or experience with you today?

Section II

In Section II of the plan we look at all of the sites that are part of the inventory, and look at the objectives we want to accomplish Garden wide. Then we begin to match up the objectives with the locations. We use a standard interpretive planning form set to record this. For each planning form for each individual site we include:

- Interpretive significance of the site or feature (why are we interpreting it?).
- Interpretive concept we want to use this site to illustrate (ecological principle, adaptation, stewardship issues, etc.).
- Site objectives – things we might need to do to prepare the site for visitors, such as add a paved walkway,

INTERPRETIVE MASTER PLANNING

viewing area, benches, etc.

- Interpretive objectives. These are the main ideas or concepts that we want the visitors to learn, feel, or do. The deliverable for that site's interpretation.
- The recommended media to accomplish those objectives, such as an interpretive panel, demonstration planting, live program, interactive exhibit, self-guiding booklet or other media or services. Also the estimated costs for developing those media.

Section III

Section III of the interpretive master plan is the Implementation and Operations section. I usually do a summary matrix of all the interpretive sites. On the vertical axis are the recommended interpretive sites from the inventory. On the horizontal axis are the recommended media, fiscal year, and costs. This way I can do a three-to-five year implementation strategy for implementation/budgeting the total interpretive plan programs, services, and media.

Section IV

One of the most important parts of the interpretive plan is the evaluation section. It is critical that you provide a strategy for pre-post testing any/all new interpretive programs, services and media to make sure they are accomplishing their objectives. If you paid $2000.00 for an interpretive exhibit – do you have proof that you are getting $2000.00 in benefits from that exhibit?

What are the benefits of doing an Interpretive Master Plan?

- It helps you organize your presentation to the visitors as to why the botanical garden has value – to them (the visitor), to the community, and perhaps regionally or nationally.
- It is the interpretation (programs, guided tours, exhibits, and experiences, etc.) that visitors come to the gardens for – the story and site experience. It help them to understand what they are seeing in real terms. Interpretive services are one of the main reasons visitors come back to botanical gardens parks, and other related sites.
- Carefully planned interpretive programs and services can help increase visitation by increasing the perception of benefits visitors receive by going to a particular facility, garden or site.
- Interpretive programs and services provide added value to any botanical garden experience and are important aspects for site marketing efforts and membership recruitment.
- You cannot have ecological tourism without interpretation. Ecological tourism is dependent upon the story of the site and the willingness of visitors to want to travel to see, learn about and experience the site.
- Well-planned and evaluated/updated interpretation brings in more visitors, more repeat visitors and more income.
- The interpretive plan provides interpretive strategies

to allow visitors create their own unique choice of ways to experience and learn about a site and its story (mass customization).

- The interpretive plan organizes the Garden's sites, trails, experiences and stories in a way that helps protect the resource while engaging and inspiring visitors.

- You will find it very hard to accomplish your overall mission and objectives using less effective communication strategies. Through your Interpretive Master Plan you also create a media plan, marketing plan, and long term development plan as well.

The Interpretive Master Plan is your way to insure that your messages are truly connecting with, and being understood by your audience in the most cost-effective way possible. Can you truly be successful with out one?

Summary

An Interpretive Master Plan provides the strategy to insure that your sites messages are truly connecting with, and being understood by your audiences in the most cost-effective and powerful ways possible. It helps you identify the most effective media and services to deliver your messages, engage and inspire your visitors, and increase visitation and memberships.

The benefits of the Interpretive Plan are huge. It helps your to focus on both short term and long term strategies to accomplish your mission. It helps you develop a phased-

in strategy for implementing new interpretive programs, services, and media. It provides a key tool in grant writing – knowing your audience, objectives, media and costs up front. And it helps you grow your audience, as well as your site. It keeps you focused on a real set of deliverables over a five year time frame or phasing strategy. And it provides a way for you to evaluate your programs and services to see if they are really working. It is your managerial green thumb for connecting your site to your visitors in the most imaginative and powerful and cost-effective way possible.

19

General Interpretive Plan Outline

This is the interpretive planning model framework that I use in my training courses, and for actually doing interpretive planning. This content outline can be modified as needed for specific scopes of work, but I feel is a minimum that any interpretive planning document should contain. A different set of planning forms are used for visitor center/museum exhibit planning (see chapter 20).

Introduction and scope of the plan
What was the scope of work the plan was to cover?

Main interpretive theme and sub-themes
(From focus workshops and site resource analysis)
- Main interpretive theme and rationale
- Main sub-themes and rationale
- Interpretive story-line flow bubble diagram

Total interpretive program/services objectives (Learn, Feel, Do)
(This is for the total interpretive program/services effort - site and/or visitor center combined. This usually comes from a focus workshop, and edited based on the interpretive site resources review.)
- Learning objectives
- Behavioral objectives
- Emotional objectives

Visitor analysis
(This is usually based on existing visitor data as doing new visitor surveys is both time consuming and expensive).

Sections of this part of the plan can include:

- Visitation numbers and trends over the past 3-5 years (graph this data).
- Basic market profile – who are the visitors, where are they travelling from, how long are they staying, gender and age variables, etc.
- Visitor experience desires or focus (why are they visiting this site?).
- Seasonal visitation trends or issues.
- School group and curriculum based interpretive planning needs and issues.
- Visitor Management Issues (relate to behavioral objectives).

Individual site interpretive inventory and story development forms

- Site resource location/inventory map. This map would show the locations of each interpretive site, feature, facility, etc. that an interpretive planning form set would be completed for (existing or proposed).
- Interpretive site index list. This is a list of all of the interpretive sites inventoried and included in the interpretive planning form sets that follow.
- Interpretive planning form sets for each interpretive site inventoried including orientation sites, facilities, trails, demonstration areas, historic sites, natural resource areas, etc.(existing or proposed).

For each planning form set include:

Site inventory form

- Site Index Number (keyed to map).
- Site Name
- Site Location (reference site index map, etc.)
- Site Description (refer to photos if available)
- Interpretive Significance (why are we interpreting this site?)

Story Development Form Set

- Main interpretive theme/topic for each individual site.
- Site objectives. These are physical development objectives such as building a stair way, add a viewing deck, etc.
- Interpretive program/services objectives. These are the specific objectives (learn, feel or do) that interpretive programs, services or media are to accomplish at this specific site.
- Recommended interpretive media for this location. This is a list of the interpretive media that could best be used to accomplish the stated objectives (i.e. self-guiding trail, interpretive panel, outdoor demonstration, guided walk, exhibit in a visitor center, etc.).
- Any budget issues or estimates. This helps make each individual interpretive planning form set a "mini" work plan for each individual site or feature that is part of the interpretive plan.

Five year implementation and operations strategy/matrix
This includes: site index number; each interpretive media or site development needs; fiscal year for implementation; estimated cost for each site/item listed. *This allows us to plan priorities and costs for actually implementing the total interpretive plan 5 years down the road.*

Evaluation recommendations
How will you know if the interpretive media you are going to purchase actually works (accomplishes its objectives), such as pre-testing interpretive panels in draft form, etc.

Appendices as needed

PHILOSOPHY, THEORY AND PRACTICE

20

General Interpretive Plan Outline: Visitor Center Exhibit Planning

Introduction and scope of the plan
What was the scope of work the plan was to cover?

Main interpretive theme and sub-themes
(from focus workshops and site resource analysis).
- Main interpretive theme for the museum and rational.
- Main sub-themes and rational.
- Interpretive story-line flow bubble diagram.

Total interpretive program/services objectives (Learn, Feel, Do)
(This is for the total interpretive program/services effort – site and/or visitor center combined. This usually comes from a focus workshop, and edited based on the interpretive site resources review.)
- Learning objectives
- Behavioral objectives
- Emotional objectives

Visitor analysis
(This is usually based on existing visitor data as doing new visitor surveys is both time consuming and expensive).
- Sections of this part of the plan can include:
- Visitation numbers and trends over the past 3-5 years (graph this data).
- Basic market profile – who are the visitors, where are they travelling from, how long are they staying, gender and age variables, etc.
- Visitor experience desires or focus (why are they visiting this site?).

- Seasonal visitation trends or issues.
- School group and curriculum based interpretive planning needs and issues.
- Visitor management issues (relate to behavioral objectives).

Individual exhibit story development forms

Floor plan location/inventory map. The floor plan would show the locations of each interpretive exhibit or experience that an interpretive exhibit planning form set would be completed for (existing or proposed).

Interpretive planning form sets for each proposed interpretive exhibit (interior and exterior)

For each exhibit planning form set include:

Site Inventory Form

- Exhibit index number.
- Exhibit name or topic.
- Exhibit location within the floor plan.
- Exhibit description.
- Interpretive significance (why are we interpreting this topic)?

Story development form set

Main Interpretive Theme/Topic for each individual exhibit.

- Interpretive exhibit objectives. These are the specific objectives (learn, feel or do) that each exhibit is to be designed to accomplish.

- Recommended Interpretive Media for this exhibit. This is a list of the interpretive media that could best be used to accomplish the stated objectives (i.e. audio device, inter-active elements, etc.)
- Any budget issues or estimates. This helps make each individual interpretive planning form set a mini work plan for each individual exhibit or feature that is part of the interpretive plan.

The planning form sets can be greatly expanded. For example, we can sometimes include computer generated graphics of how a exhibit might look in place, etc.

Implementation and operations strategy/matrix

This includes: Site Index Number – each Interpretive Media or Site Development needs – Fiscal Year for implementation – estimated cost for each site/item listed. *This allows us to plan priorities and costs for actually implementing the total interpretive plan x years down the road.*

Evaluation recommendations

How will you know if the interpretive media you are going to purchase actually works (accomplishes its objectives), such as pre-testing interpretive panels in draft form, etc. We strongly recommend pre-testing any new interpretive exhibits before final production.

Appendices as needed.

21

Exhibit Planning Worksheet

Exhibit Planning Worksheet

Project:
Client:

Exhibit #:
Theme or topics:
Exhibit title:

Main concept to be interpreted:

Exhibit objectives
Learning objectives:

Behavioral objectives:

Emotional objectives:

Audience:

Materials available for this exhibit (working list):

Exhibit Presentation Ideas:

22

Exportable Interpretation:
Ideas To Go Away With

So what is "exportable" interpretation? The concept came very clear to me almost by accident while working on an interpretive plan for a Conservation Education Center in Iowa. Our team had visited several nearby nature centers to review their programs, services, exhibits, etc. so as not to duplicate anything at our project site. The thing that was lacking from all of the centers was the fact that none of the programs or exhibits had anything on how the visitor might use information being interpreted to them! None of the ideas or information were of any use outside of the nature center, park, forest, or site boundary. The concepts could not be exported for use anywhere else. They were dead-end programs!

The two key questions for planning exportable interpretation:

1. Why would a visitor want to know that? If you can't answer this question, then why would a visitor want to come to this program or look at the exhibit in the first place?

2. How do you want the visitor to use the information that you are giving them? If you don't want the visitor to use the information, then why are you giving it to them?

In other words, an interpreter may find knowing the names of 100 wildflowers to be of use, but most visitors have no need of all that information. We are giving lots of answers to questions that no one is asking! Of the 20 or more plants you identify for visitors on a wildflower walk – how many do you think

they will actually remember 10 minutes after the programs is over or by the time they get home? And, how will they *use* this information once they get home?

Using the exportable interpretation concept

The exportable interpretation concept means that the planner:

1. Asks the two questions noted above, with particular interest to question #2.

2. Considers activities, handouts, demonstrations, etc. in the presentation of the program or exhibits to motivate, support, and encourage the visitor to use the information being presented in some way.

3. The concept and information should be able to be used not only within the boundaries of the site, but should be able to be used by the visitor when they leave the site.

Given limited time and budget for programs, or visitor contact, why would an interpreter want to give visitors non-usable information when, given the same time and cost, can encourage visitors to *do something*? Here is an example:

- *Non-exportable program theme:* We have over 20 different species of trees in our park.
- *Exportable program theme:* There are many benefits to planting trees at your home and throughout your community.

Let's take this last example and expand on it by developing the interpretive program objectives for the program:

- The majority of visitors will learn several different tree species that are native to this region and habitat requirements of each.
- The majority of visitors will learn at least one way each tree benefits wildlife, and people.
- The all visitors will feel encouraged to plant a new tree at their home, or donate a tree seedling to be planted at some local park or site.
- All visitors will receive a handout with three different tree seeds that they can plant at home.

As you can see from these objectives there is a focus of the program to, first, use the resources of the site for examples and inspiration; and, second, to transfer that information and inspiration into some positive action. Note the objective of having a handout to give each visitor at the end of the program.

Other exportable interpretive program or exhibit concepts (desired results) can take a variety of forms such as:
Do not pick up Indian artifacts or pottery shards at any historic site you visit.

- Do not pick wildflowers at any park natural area.
- Recycling helps everybody – here are three simple things you can do at home.
- Join a nature or history club to learn more about...
- Go and visit other sites to keep on learning.
- Go to the library and read more about the subject.
- Volunteer at a park, forest, nature center or historic site.

Summary

The concept of exportable interpretation simply means that visitors can continue to use the information you interpreted to them on site, after they have left your site. The use can be psychological in nature, such as valuing the natural world or understanding and supporting a particular type of resource management practice. The use can be physical in application, such as using native plants to landscape a yard, or recycling at home or office. The important thing is that the visitor can use the information interpreted to build on in some way.

23

Is Your Scenic Byway Interpretation Sustainable?

The project is done, the scenic byway is completed, the interpretive plan done, and all of the thousands of dollars spent on interpretation media to bring the byway story alive to your visitors are in place. You are finally all done? No! You have really just begun.

The problem with a lot of byway interpretation is that it was not planned to be sustainable. Often done by contractors' who are not trained interpretive planners, byway interpretation tends to be lots of information, not inspiration/interpretation and tend to be answers to questions that no one is asking! The interpretation was done to simply complete the project, and never tested or evaluated to see if the interpretation actually worked – successfully transmitted any messages to visitors – before the final panels or other media were completed. It was not planned to be a living, on-going interpretive system in need of monitoring and yearly updating. Most of the interpretation media are final! Once the panels are up, or the booklets printed, it's all done! Everyone goes home. And that's the problem.

Now a year or so has passed, and most of the residents/ visitors have seen the panels, or done the booklet directed drive. Once you have done it – you've done it. So if the byway group is monitoring the byway tourism draw, they will probably see a drop in interest from locals and many visitors over time. The story and presentation are old news and the scenic byway slowly returns to being what it always was – a scenic road.

Is your byway interpretation going to be sustainable?

By sustainable I mean that your byway will function for many years in successfully being a tourism draw, as well as a community educational experience and resource, rather than have high interest at the start, and then less and less interest as the years pass. Here are some questions to help you think about your byway sustainability.

1. Will you evaluate your byway interpretation to see if it actually is successful in interpreting your story to visitors? If you are spending tens of thousands of dollars on interpretation – spend part of that to make sure the stuff works!

2. Will you have more than one market group the interpretation media are planned for (the concept of mass customization) to increase the diversity of market groups who you can attract to your byway? How will your byway interpretation plan be marketed for such audiences as: school groups, history buffs, natural history buffs, botanists, geologists, etc. What media will you have for each diverse group?

3. After the project is done, who will be taking care of the byway interpretation to make sure that interpretive panels are in place and haven't been vandalized, and other interpretive media is updated? For example, the Ohio River Road Scenic Byway goes through three states! Just who is going to make sure the interpretive media for that byway is kept up and maintained and that the interpretation is a seamless experience for visitors in the future?

4. How will you keep your byway interesting and fun for visitors after they have seen the initial panels or booklet many times? Why should they do the byway again?
5. With gas prices going up, what are the benefits to visitors to do a scenic byway drive? What's in it for them? What do they get in return for their investment of time and money to drive the byway? What benefits are you marketing?
6. And the last question – if you spent tens of thousands of dollars on your scenic byway interpretation, just how do you really know that you are getting tens of thousands of dollars in benefits from that interpretation? Where is the proof of pay back?

Seen it, done it – what's next?

The fact is that byway interpretation, like any other interpretation, can get boring after a while, and in need of freshening up! And if the interpretation was boring to start with, this becomes critical in the long-range interpretation sustainability and marketing plan. Quite simply, byway interpretation has to be updated – in some cases seasonally, and in many cases yearly or at least every two years or so. So who is going to do this, and with what funding? With out this freshening up, it is hard for byways to maximize their tourism draw potential and be sustainable as a tourism generator for communities and regions more than a few years after their initial development.

Here are some ideas that might help.

During the initial byway interpretive planning process, make sure that sustainable interpretation is in the plan. This would include planning for changing and updating interpretive media at select sites over one to five years down the road.

If you know you'll need seasonal interpretive panels for some byway locations, have them all done at once during the plan/design/fabrication stage. That way you will have the panels ready to go for seasonal installation, and you can advertise that "new panels are now up" for seasonal marketing of the byway.

While you can produce one printed byway booklet or CD for interpretation, you will probably need several different ones – for different market groups. Here is a way to serve these visitor needs and not break the bank. Produce several different themed self-guiding booklets for different market groups such as:

- Byway geology and glacial history.
- Early pioneers and settlement in the region.
- Historic cemeteries and their stories.
- Historic buildings and architecture.
- Historic people and places.
- Byway roadside plants and animals.
- A parents guide to the byway.
- A child's coloring book for byway features.
- K-12 teachers guides for byway experiences and education.

· The spring (summer, autumn and winter) byway guide.

Produce these materials in full color as word documents on your computer and then have them posted and available on the byway web site. That way visitors can print off (with their own paper and ink) the guide(s) they are most interested in. For those who don't have computer access, have a few printed copies available at byway contact points where visitors can have one printed while they wait, or check one out and return it later. These different guides can have different physical stops for each guide, located by mile marker, visual cues, odometer readings, etc. Again, this should be part of the initial interpretive plan for the byway to determine which micro market groups you will want to attract, and the interpretive topics to be developed for the diverse market groups you are targeting, and the appropriate interpretive stops for each themed guide.

This gives you maximum flexibility for your byway interpretation, including being able to easily update each booklet, but not require you to have huge printing costs and runs.

The sustainable interpretation planning basics
In planning for sustainable byway interpretation and related media, here are some basic interpretive planning steps to consider. This should be a part of *any* byway interpretive master plan.

1. What is my main byway interpretive theme and sub-themes that I will need different interpretive media and experience for? Is this theme and sub-theme(s) marketable?

2. Specifically, what are the Learning, Behavioral, and Emotional interpretive objectives that I want by byway interpretation to accomplish, both for the total byway experience, and for each individual byway interpretive site, location, or stop?

3. Who are the different macro and micro market groups, and thematic market groups that I will want to attract, and what are their different interpretive media, and subject matter needs and interests? Will these groups' interests change over time?

4. What are the different sustainability issues of the byway – seasonal sites/attractions, fixed market groups (the same visitors over and over again), changeable interpretive panels, seasonal tour route media, and other related needs to keep things fresh.

5. What will the interpretive media mix need to be (seasonal, thematic, market driven) for sustainable byway marketing over the next 5 plus years? What media/services will need to be seasonally or annually updated, why will it need to be updated?

6. What will the sustainability implementation costs be (changeable media, services, planning and design, etc.) over the next 5 years?

7. How will the byway interpretive and tourism marketing

be tracked and evaluated to make sure both the marketing for the byway, and the on-site interpretation are working and accomplishing their stated objectives at an acceptable level?

8. What will the strategy be to see if the byway interpretation is indeed having a positive affect on tourism and that the interpretive investment is yielding a pay back?

Summary

Scenic byways are generally a huge investment in time and money. While most of the effort goes to all of the up-front and start-up costs of the byway development, including developing and installing interpretive media, little equal effort seems to go to the long term sustainability planning of byways as a interpretive heritage tourism asset. Without this kind of sustainability planning for updating interpretive materials and interpretive experiences, and developing a wide range of interpretive options for different market groups, the true potential of byways for providing long term heritage tourism benefits to communities and regions can be easily lost. As much effort needs to be placed on the interpretive planning for *after* the byway is competed – and maintaining newness and freshness to the byway interpretive experiences – as was provided for the initial interpretive start-up. Otherwise seeing a long term profit or benefit from the initial byway investment will be hard to find and visitor interest in the byway interpretive story will fall as it become old and outdated.

24

Planning for Interpretive Training Courses

Sometimes teaching an interpretive training course or workshop can be a bit daunting. Here you are – a professional interpreter – surrounded by other professional interpreters, all waiting to here what you have to say, learn or improve on a new skill, get a shot of enthusiasm, or more than likely, all of the above. So how does one prepare to plan, design and present a successful interpretive training course or workshop? After 27 years of doing interpretive training courses, from university teaching to providing interpretive training for agencies worldwide, here are some things that I learned over the years that can really help make training courses a success.

The first step

When beginning to plan your training course the first thing to consider is exactly what you or your client want the training to accomplish. What information, skills or improved abilities is the training supposed to accomplish? To this end, I begin with working out just what the measurable objectives of the training are:

- Learning objectives: What information do you want the participants to remember and why?
- Behavioral objectives: How will the participants use the information. What skills will they be able to demonstrate after the training is completed?
- Emotional objectives: How will you make the training fun – and fill the participants with self-confidence and enthusiasm?

The pre- and post-test and measuring training success
With objectives in hand, I often create a workshop pre-test (testing against the objectives of the workshop). I want to know how much the participants already know about the subject matter – do they already know Tilden's Principals for example? With the post-test (same questions as the pre-test) I can measure the change in knowledge that occurred based against the pre-test scores. The pre- and post-testing is one of the only real ways to measure success of the training.

The other way to measure the success of the training is by practicum and products. For example, in interpretive panels planning courses I have participants actually develop interpretive panels. In the course they are walked through the interpretive planning process for their project (objectives, theme, use of Tilden's principals, etc) to develop a mock-up panel like the one shown below.

Course objectives and evaluation strategies – what next?
With my course objectives in hand, the next step in putting together the training is to have an understanding of the participants. What skill or information levels do they currently possess? Will the workshop be one teaching skills that they will be using immediately when they return to their own sites? Or will the training be for other kinds of information that they will use later on?

Teaching aids?
After considering the course objectives and the audience,

Figure 1: It is the goal of practicums, such as the panel exercise, to see if the concepts presented in the training can be turned into real products. This is one example where it is easy to see that this participant really understands the concepts and was able to put them to use.

the next thing I usually think about is what teaching aids will be needed. Will I need a course textbook or manual, handout materials, overhead transparencies, completed media examples, guest speakers, AV or videos, or other teaching aids? I begin by lining up the objectives and subject matter I am planning to present with what I think I will need to use to provide visual and audio examples of the concepts.

Lesson plans anyone?

Depending on the length of the course (one day or five days – or a semester) I like to develop lesson plans. Lesson plans are a way for me to outline – on paper – the objectives I want

each workshop session to accomplish, the activities that I will be doing, and any associated teaching aids that will be required. I can also send the draft lesson plans to the agency representative I am doing the training for to make sure that all of their objectives and outcomes are there.

A sample lesson plan page for an introductory interpretation course is presented later in this chapter (Fig. 2).

Session objectives and outcomes

As part of the workshop planning process, we must have training objectives for each workshop session we plan to present – these appear on the lesson plans as well. For example: As a result of this session, all participants can write at lease one example of a learning, behavioral and emotional objective. That means that for this particular workshop session, the instructor has to present the information, give examples of each type of objective, and have a practicum where each participant writes one example of each objective type.

All workshop sessions should have objectives, which relate to the overall objectives of the total workshop session, and relate to the workshop pre-post test exam questions. Again, these would appear on the lesson plans to guide the instructor as to how to best illustrate the concept the objectives are relating to.

The lesson plan (Fig. 2) illustrates one page of a 22-page lesson plan set. You can see how the session objective is presented and the first exercise used to illustrate learning concepts and principals is laid out.

Developing practicums

One of the key parts of any interpretive training program is the hands-on or practicum part of the course. In general, people remember: 10% of what they hear; 30% of what they read; 50% of what they see; and 90% of what they do.

With this in mind I like to develop lots of hands-on activities as part of the training courses. I want participants to take home products, not just information. For example, in a training course on interpretive program planning I have participants divide into groups of about 4 people each. Give them an interpretive program theme and objectives, and about hour to plan and rehearse a 5-minute presentation to the group. The presentation must:

- Illustrate the theme.
- Accomplish the stated objectives for the presentation.
- Consider the audience the presentation is presented to.
- Use interpretive communication principals (provoke, relate, reveal, etc.)
- Involve the audience (some or all) in some way.

Thus, the practicum is the culmination of the training course, where the theory and ideas are turned into real products.

Planning for training summary

So in general the basic steps I use in planning for my training courses are:

- Understand clearly the objectives of the training course.

- Understand your audience.
- Have an evaluation strategy (pre-post test, practicum projects, etc.) to see if the training objectives are accomplished at the end of the workshop.
- Think through the kinds of teaching aids you will need.
- Develop a detailed lesson plan to help you plan your presentations.
- Make sure that there are lots of hands-on learning experiences.
- Use interpretive techniques to actually present or interpret to the class yourself.
- Make sure that the participants have fun and leave with more than just information.

Instructors Lesson Plans		Page – 1 of 22
Day: 1	**Subject: Interpretive Services**	
Time	**Lesson Details**	**Visual Aids**
	Objectives: Upon the completion of this topic, each student will be able to describe three learning concepts and three learning principles. **Learning Concepts** This section involves several hands – on learning activities with instructions as to how to conduct each activity. **Exercise #1** Begin by using the Beatles tape. This tape has two versions of the Beatles song – the original version, and a "classical" version of the same song (I Want To Hold Your Hand). First plan about two minutes of the "classical" version (the first section on the cassette tape). 1. Set up the tape so that it is ready to go at the beginning of the class session with the classical version first. 2. At the start of this exercise tell the students that you want them to listen to this piece of music and to write down what ever the music makes them think of or feel. Also, if they know the name of the composer, write that down too. 3. Plan about 2-3 minutes of the tape. Then stop the tape and give the students a few extra minutes to write down their thoughts about it – what did the music piece make them think of or feel? 4. After the students have had time to write down their comments, ask each students what their response was – what did the music make them think of. Write down a sample of the responses on the flip chart (take about 10 responses – ask for any different ones than were already given and presented on the flip chart). 5. After everyone has had a chance to respond, and looking at the examples on the flip chart, ask the students "so what did you learn from this exercise?"	Beatles Tape Flip chart pad for recording responses from the participants.

Figure 2: Lesson plan extract

25

Planning Interactive Walking Tours

With the increasing interest in heritage tourism development, particularly for small communities, there has been growing interest within communities to develop historic walking tours as a draw, adding to the collection of activities visitors can do when visiting. These walking tours may be of the downtown area's historic buildings and related heritage sites, or for a community's historic district. A common question I am asked is how does one go about planning these kinds of tours? This chapter is designed to service as a basic guide in how to plan and design any community walking tour – questions to ask and answer, and some general planning considerations.

The basic planning process

The basic interpretive planning process for developing walking tours considers the following six steps.

First, *consider the resource(s) to be interpreted.* With a street map of the community or historic district, do an inventory of the potential stops for a walking tour. Inventory historic homes, historic gardens, architecture, industry and related sites of interest.

Make a list of all of the sites being considered for possible interpretive stops, and plot their location on the street map.

Make a list of the main interpretive theme or concepts that each of the potential interpretive stops would best illustrate. What is the main interpretive feature or attraction – architecture, the home of a historic personality, the site of historic business, etc? For example, an interpretive theme might be: *The early architecture of our homes and buildings reflects*

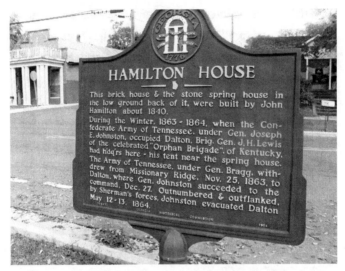

Figure 1: Some historic homes may already have an information panel with them, such as the Hamilton House, in Dalton, GA, which is listed as a National Historic Landmark.

our strong Swedish heritage. Another theme example might be: *Our community buildings reflect three different architectural or cultural styles or influences.* Another theme example might be: *The Ohio River was responsible for our community's early growth and history.* Think of the theme as the *one thing* that, if nothing else, you want the visitor to remember or learn about your community by the end of the tour.

Do an analysis of all of the sites you are considering and look for those sites that illustrate a common theme or story. Also consider the relative importance of each site, facility or home. Is this the best example of..., the only example of..., etc. From your analysis of all possible stops on a walking tour, begin to cull out the potential stops with this in mind:

- A walking tour should not take more than an hour to walk – longer walks, particularly on hot summer afternoons, tend to wear the visitor out, particularly older visitors.
- Try to limit the tour to about 10 stops. This is about the most information that most visitors can remember for interpretive stops. Make sure that each stop selected is a good example of the main interpretive theme. You can develop a more detailed architectural guide for the experts that might want one, but most general tourists just need an executive summary.

Review the stop locations on your street map to look for and consider:

- Where do you want the tour to start and end (it should be a loop)?
- Are there any safety issues associated with the tour (streets to cross, etc.)?
- Will each stop be easy to find or will special directions be needed in the tour book?
- Will the visitors be in the shade or need rest stops to sit down?
- Will there be any conflict with tour walkers and property owners?

Is the interpretive theme or message you are considering interesting? Will visitors want to know this? Will you be able to market the tour? What will visitors see, discover and

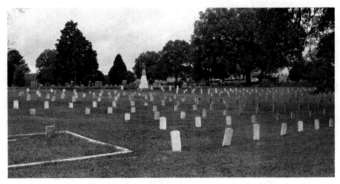

Figure 2: There is a lot of interest in community historic cemetery interpretation as part of community tours – if a cemetery is close by to the tour route. What market groups do you think would have the most interest in cemetery interpretation as part of their tour?

experience on this tour? What are the *Oh My* stories?

The second step in the tour planning process is to consider just what you want the tour to accomplish – its *objectives*. In this part of the planning process I consider the objectives for the total walking tour, and interpretive objectives for each stop on the walking tour. Here are some typical objectives for an interpretive walking tour: The majority of visitors, upon completing the walking tour, will:

- Be able to describe the three main architectural styles of the buildings in the historic district.
- Be able to describe why only these architectural styles were used and not other ones.
- Learn how this community was associated with a major Civil War battle.
- Understand how the early farming industry affected the community's growth.
- Feel that preserving historic homes and local history

is important and benefits everyone.
- Gain a sense of empathy for the early settlers.
- Want to learn more – buy a book on local history.
- Want to attend other interpretive tours or programs.

These are general examples of interpretive objectives. The objectives for your walking tour would be specific to your resources and your desired outcomes.

The third – *Who* – part of our walking tour interpretive plan is where we consider just who the visitors are that we are trying to attract. This is important as it helps focus not only on what interpretive stops we will make on the tour, but the kinds of examples and stories we share with them. Each different market group might need some different interpretive considerations. So think about your intended audience – will they be:

- Local residents who have lived here a long time.
- Local residents who are new to the community.
- Local and/or regional school groups (will the interpretation need to reflect the schools social studies or history curriculum?).
- Tourists from within the state (familiar with state history and somewhat familiar with your site, community, history, etc.).
- Tourists from further away or from other states that have no knowledge about your history or community at all.

- Tourists that are older (over 65) – who will be reminiscing about their own past?
- Families with young children.
- Architecture students or experts.
- Historic preservationists.

The list can go on, but you get the idea here. You can begin to see how each group might need a little different take on your presentations for each site. The trick is, as you are probably only going to do *one* walking tour brochure, to make you best guess on the market group that will comprise the *majority* of the visitors likely interested in learning about or experiencing the stories your walking tour will present. Of course you can do some creative things like develop an adult guide and a children's guide, or a brochure that services as a teachers guide for the walking tour with suggestions and information that the teacher can use at each site to have students look for, find, etc.

Fourth, media selection. Once we have determined our resources to be interpreted (theme, route, etc.), our outcomes (objectives the tour is to accomplish), and the kinds of visitor groups that would be the most likely users of the waking tour, we need to think about the best media to be used for the walking tour itself. Some of the most common media to consider:

- Self-guiding booklet. This can be an effective media that would have an introduction to the tour, its theme and sites; have a good and easy to follow map with the route and directions easily to follow; and have

Figure 3: Interpretive panels for walking tours can help visitors visualize the past for historic buildings, like this panel for the Lincoln Tavern, in Kentucky.

good interpretation and graphics/photo(s) for each stop on the tour. The text would need to be kept short (not more than about two 50 or 60-word paragraphs), and use at least 12 to 14 point type so that it is easy to read. Production costs will depend on the number of pages needed, type of paper used, number of plates for photos, number of colors used, and number of copies needed for the initial print run. Note: do not print photos on colored paper, like light brown, light gray, etc. This will wash out the black and white photos. I recommend only printing photos on white paper for the best contrast. Get several different bids from different printers for production costs.

- Interpretive panels at each stop. This is more expensive (about $1000 to $2000 per panel) and you would still need a printed map with the route.
- Audio tour. This would be the same tour as the printed brochure, but have narrators doing each stop and giving directions to the next stop. You might or might not need a map to go with it, depending on the complexity of the tour route. Can make the tour more affective and emotional.
- Video tour – a live guide that directs you to each stop, shows illustrations or historic photos of how the site used to look, and can use background music, etc. This allows for a full range of visual creativity, and the tourist can buy the video as a souvenir

Some of the things to consider when making your selection of which media to select are:

- Will these be provided free, or for sale?
- If it is for sale, how do we do our accounting?
- What is our budget?
- How many visitors might want to do the tour?
- How will the materials be distributed or re-stocked and by who?
- How will visitors learn where to find the tour guides/materials?
- Who should they contact if they have any questions about the tour or the tour materials?
- What will the projected cost/contact and cost-

effectiveness of the tour be (what are we getting in return for our walking tour investment)?

Fifth, implementation and operations. This part of the walking tour plan is where you list and consider just how the walking tour will go from idea to reality. I always like to make a checklist of things that have to be done or considered. Here are a few of the things you might need to consider for the list – feel free to add to this list based on your needs:

- What is the total budget for the project?
- What is the budget for the planning?
- Who will do the site/tour route planning and tour stop selections?
- Who will develop the copy for the tour stops?
- Who will put together the draft walking tour guide, including graphics or photo selections?
- Who will be responsible for approving the walking tour copy and graphic selections (and historical accuracy)?
- Will the tour be pre-tested to make sure it works using some mock-up tour brochures or draft CDs, before any final production?
- Which media will be selected?

For example, if a self-guiding brochure was selected as the best media:

- Who will do the final photo-ready layouts?
- Do we need permission to use the photos in the booklet?

- Who will do the printing?
- What budget has been allocated for photo-ready design?
- Who will approve the final photo-ready design.
- What paperweight and printing colors will be needed?
- How many copies will be needed for the initial run?
- What is the budget for printing?
- Who will distribute the walking tour brochures?
- How will the walking tour be advertised?

Make a checklist of all of the steps you will need to follow (and who is responsible for each step – particularly approvals). You should also add in time frames for completing each task, such as three weeks for planning, three weeks to complete the draft designs, and two weeks for printing.

Does it work?

To me this is the most important part of the planning process, the evaluation of any draft materials to make sure that the objectives are accomplished. This can be easy or more complex depending you your time and budget. But always budget for the pre-testing of any walking tour. For example with a walking tour, have some visitors take the walking tour with a draft guide to critique or consider:

- Were the directions clear and easy to follow?
- Was the map clear and easy to follow?
- Could they find all of the stops?
- Did they understand the interpretation at each stop

(objectives)?
· Was the tour too long or just right in length?
· Did they need a rest stop – a place to sit down?
· Was the tour interesting, provocative, boring?
· Would they recommend the tour to others?
· What did they enjoy the most – the least?
· Was the tour right for most market groups, only one market group? Who liked the tour the most from the mix of visitors who you had test it for you?

If you don't have the time or budget to do it right the first time, when will you have the time and budget to do it over?

Summary

In this chapter, I have given you some of the main points to consider when planning a community or historic district walking tour. This was a generic consideration, so feel free to add in any specific needs or considerations for your project. Walking tours can be a good heritage tourism addition for any community if well planned and promoted. I hope these ideas will help you to have a great tour and help celebrate and share your community's history with others.

References

Pine, Joseph B. and James H. Gilmore. 1999. *The Experience Economy*. Harvard Business School Press, Boston, MA.

Von Oech, Roger. 1989. *A Kick In The Seat Of the Pants*. Harper & Row Publishers, New York, NY.

Von Oech, Roger. 1990. *A Whack on the Side of the Head*. Warner Books, Inc. New York, NY.

Veverka, John A. 1992. *An objective look at interpretation*. John Veverka & Associates, MI.

EXHIBIT DESIGN

26

Tips and Concepts For Planning Truly Interpretive Exhibits

A mind once expanded with a new idea never regains its original proportion.

Are your exhibits giving answers to questions that no one is asking? Are they full of information but not translation of the topics in terms that the visitors can understand or relate to? Do the look nice (they better – you probably paid a lot for them), but the visitors don't seem to learn or remember anything from them? If this is the case, you don't have interpretive exhibits. I have noticed over the years that almost every exhibit is called an interpretive exhibit, while most of them don't actually interpret anything – they just simply present information. The problem is that quite often there is a lack of knowledge as to what makes an interpretive exhibit interpretive.

The goal of this chapter is to provide a general introduction into what makes an exhibit interpretive, and some hints on how to make your exhibits more effective in translating its message from the language of the curator or resource expert to the conceptual language of the visitor. Remember, *you* are not your audience.

What is an exhibit?
An exhibit is an array of cues (visual, auditory, sensory, etc.) purposely brought together within a defined boundary for a desired effect.

Reasons for exhibits?
In general, I believe that exhibits are probably one of the least

cost-effective methods available for communicating with visitors – particularly if they have not been pre-tested prior to their final construction. But, given that, here are some reasons for exhibits.

- Tell a story in an ordered sequence or fashion.
- Tell a story that can't be told or illustrated on site.
- Bring artifacts and stories to places where the visitors are.
- Bring extremes into human scale (i.e. a three-foot model of a one-inch square of soil).
- Allow visitors the freedom to pace themselves.
- Allow staff to do other things.

What is interpretation?

In planning interpretive exhibits, we should have an operational definition of what interpretation is. The definition I prefer is:

> *Interpretation is a communication process designed to reveal meanings and relationships of our cultural and natural heritage, to the public, through first hand experiences with objects, artifacts, landscapes, or sites.* – Interpretation Canada – 1978

How do interpretive exhibits differ from general informational exhibits?

An interpretive exhibit makes its topic come to life through active visitor involvement and extreme relevance to the everyday life of the visitor/viewer.

Interpretive exhibits should:

- Employ interpretive techniques and principles (Tilden's Interpretive Principles).
- Provoke the visitor's interest or attention.
- Relate to the everyday life of the visitor.
- Reveal the main concept in a unique, creative ending or viewpoint.
- Address the whole – illustrate the main interpretive theme of the gallery or exhibit group of which it is a part.
- Have message unity (design elements that support the theme).
- Be objective and outcome-based (have learning, behavioral and emotional objectives).

The two basic questions an interpretive exhibit planner must ask and answer as part of the exhibit interpretive planning process are:

1. Why would a visitor want to know this (information or topic that the exhibit is presenting)? If you can't think of reasons visitors would want to know this – how can you provoke them into wanting to look at the exhibit and interact with it?

2. How do you want the visitor to use the information the exhibit is presenting? If you don't want the visitor to use any of the information in the exhibit (or the visitor can't use any of the information or concepts presented in the exhibit), then why are you giving the information to them?

There are not any right answers, just questions to be considered. The answers will help plan and design more visitor friendly and cost-effective exhibits.

The psychology of the exhibit: exhibit load
Exhibit load is the term I use to describe the amount of time and energy (both physical and psychological) that each exhibit requires the visitor to use up in interacting with that particular exhibit. Think of the visitor coming to a museum or interpretive center with 100% enthusiasm, interest, and excitement when they first enter the exhibit area. As they move through the exhibits they are using up emotional energy and interest in the exhibits begin to drop – they start to get psychologically tired and overloaded with information and stimuli. And, usually within about 45 minutes, the visitor has had enough and heads for the gift store or the lunchroom.

Usually the exhibits with the highest load are the interactive ones that require mind and physical coordination – more thought process (and easier mental fatigue), and the low load exhibits are the more passive ones, such as flatwork graphics, collections behind glass, paintings, etc.

The exhibit classification matrix (Fig. 1) gives you one way to help determine the general load of an exhibit with the type 1 exhibits having the most intrinsic interest and type 3 exhibits having, in general, the least interest for visitors.

So just what does this matrix mean? Here are some examples.

Type 1 exhibit: The exhibit moves or has motion and the

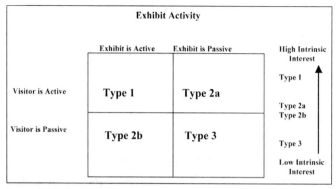

Figure 1: Exhibit Classification Matrix

visitors moves or does something – an interactive exhibit, such as holding a live animal, or a computer activity such as the examples below. In General, they have the most intrinsic interest for visitors.

Type 2a exhibits: The visitor can do something but the exhibit is inert, such as a hands-on touch table or touching an animal skin. Shown below are some examples of type 2a exhibits.

Type 2b exhibits: The visitor is passive (just looks) while the exhibit does all of the work, such as watching a video, watching a live animal in a zoo or aquarium, or watching a working model.

Type 3 exhibits: The visitor is passive (just looks) and the exhibit is passive (does nothing) – looking at collections in cases, looking at flat work graphics and paintings for example.

The idea here is that a the visitor goes from cell rank 1 to 2 to 3 there is generally a decrease in the intrinsic interest they have in those kinds of exhibits. Thus, more use of interpretive

techniques are required for type 3 exhibits than type 1 exhibits. Research has shown that people are more interested in dynamic, animated, changing stimuli than in inert flatwork (USDA Design Office Research Report – c. 1996). If you want to see this concept in action, go to any museum or interpretive center and watch your visitors.

The effect of exhibit content on visitor load factors

We also know from years of experience and research that the content of an exhibit also plays an important role in the intrinsic interest that visitors have towards exhibits. Visitors have more intrinsic interest in the real thing than replicas, graphics or text.

As an example:

- Here in this case is Davey Crocketts Rifle – imagine the adventures it has been a part of.
- Here in this case is a replica of Davey Crocketts Rifle (no adventures).
- Here is a photo of Davey Crocketts Rifle.
- Here are 1000 words describing Davey Crocketts Rifle.

We have a decrease in intrinsic interest as we move from real things to text.

In the 20-plus years I have been involved with exhibit planning, I have found is to have a good diversity of exhibit load mix. I like this general formula for most interpretive centers:

- 25% Type 1 exhibits

- 50% Type 2 exhibits
- 25% Type 3 exhibits

Of course this depends on the type of site you are working with. Most science museums are mostly type 1 exhibits. The problem is that it is easy to have exhibit burn out in the visitors, particularly since there is often not a strong focused interpretive theme in many science centers.

Art Museums pose the opposite problem of being all type 3 exhibits – unless you know what you are looking at, they can be boring for some visitors and not a lot of interpretation goes on except at the more creative art museums with education/ docent staff that can make the art come to life for the visitors.

You can use this concept of exhibit load and intrinsic interest to mix and match exhibits. For example, if you had an exhibit on Native American Stone Tools and had a lot of originals in a glass case for visitors to see, you would have a type 3 exhibit. But if you added replica tools for them to pick up and guess how they were used – what kind of tool they were, you would have a type 2a exhibit – of more intrinsic interest. You can have exhibits that use all four exhibit types within one exhibit as well.

Hands-on needs minds-on to work properly

One of the big problems I have with some exhibits where people can touch things is the lack of the reason or learning concept connected with the touching. Take touch tables for example – a standard in most nature centers. So a person picks

up and looks at a deer antler – then what? They put it down and pick up a turtle shell – then what? What is the point in the hands-on activity? To have these exhibit really work you need to have some minds-on planning or outcomes for the exhibit activity. This exhibit could be enhanced by asking: "Pick up the deer antler and see how many different tools you think you could make from it – what would those tools be?". Now the mind has a focus or objective that goes with the activity.

Planning interpretive exhibits: outcomes please
In planning interpretive exhibits the element that is most important in the planning process (but almost always left out of the process) is a clear understanding of what exactly you want the exhibit to accomplish – its objectives. I would encourage every interpretive exhibit planner to make sure that objectives are created for every exhibit, in writing, and make sure that the exhibit designer gets and follows the intent of the objectives. How can an exhibit designer design a cost-effective exhibit if they have no idea as to what the exhibit is supposed to accomplish? When planning exhibits I use three kinds of objectives:

1. Learning objectives: those objectives that state just what you want the visitor to learn or remember such as: upon completion of interacting with this exhibit the majority of visitors will be able to list three ways plants have been used for medicine. Or: upon completion of interacting with this exhibit the majority of visitors will be able to describe the concept of lift in making airplanes fly.

2. Behavioral objectives: These are objectives that address the question: how do you want the visitors to *use* the information the exhibit is presenting to them? This is what you intend the visitor to do. An example might be: upon completing interacting with the exhibit the majority of visitors will want to contribute to preserving historic homes in some way. Another example might be: upon completing interacting with this exhibit the majority of visitors will want to learn more about the history of mound builders. The behavior can be psychological in nature as well such as: the majority of the visitors to the interpretive center will want to make return visits more often and tell their friends what a great place this is to visit.

3. Emotional objectives: Emotional objectives are those objectives that will have the most impact on the visitors long term memory (and help accomplish the behavioral objectives of the exhibit). They are important as they help the designers decide on exhibit graphic selection, colors, and use of sound effects, label copy development and more. Some examples of emotional objectives: upon completion of the exhibit viewing the majority of visitors will feel a sense of sadness about children working in the coal mines in the late 1800's. Or: upon completion of viewing the exhibit the majority of visitors will feel an increased importance in quitting smoking. Other emotional objectives might be to increase pride in a local heritage, and even to have fun learning.

Exhibits and drawing power

When you are planning how your interpretive exhibits will work with visitors, here are some of the exhibit contact steps that occur:

First: exhibits must have *attraction power*. This means that when a visitors walks into an exhibit gallery or room and scans the exhibits, there has to be something in the exhibit (provocative header, powerful graphics, interesting artifacts, etc.) that will draw or attract the visitor to that exhibit.

Second: comes *holding power*. The exhibit has enough material (copy, artifacts, content, etc.) that once the visitor sees the exhibit up close, they are provoked or curious about it enough to stay and spend more time with it.

Third: *engagement power*. There is enough curiosity raised (holding power) that the visitor is willing to follow through and read label copy, do the hands-on activity, watch the video, etc.

These first three steps only take about 10-15 seconds to work through. You can watch this process in action yourself by observing visitors in a museum or interpretive center.

After the visitor has read or interacted with the exhibit, the next steps in the sequence are:

- *Understanding*: The material was presented in such a way (relate, reveal) that the visitor understands the main concept(s) presented in the exhibit. This then leads us to the final part of the exhibit communication sequence which is...

- *Outcomes*: If the visitor understands the message or

story that the exhibit presented, then the final outcome of the exhibit is that its Learning, Behavioral and Emotional objectives have been accomplished. This makes the exhibit successful.

Exhibit dollars and sense – what do we know about exhibits?

If you are involved in doing planning for new exhibits for a facility, or revamping a current gallery, here are some general rules of thumb in trying to determine your exhibit budget.

An average cost for new exhibits for a new exhibition (an empty room) is about $300/square feet of exhibit space. This cost may go up or down depending on specific exhibit content (computer, hi-tech exhibits, etc.).

Out of the total cost of the exhibit project, plan to have about 25% of your total budget for design and about 15% for delivery and installation.

What this means is, if you have $1.00 for your total exhibit budget, you only have 60 cents available for the actual exhibits themselves (construction).

If you decide to do one contract for design and a different contract for build, you can probably deduct another 10% off of the exhibit budget for the designer to develop your design bid documents for the construction of the exhibits.

Time

The average time you should allow for most projects is about 9-12 months for the design part of the project, and another 9-12 months for the build part of the project. In general, it will

probably cost more and take more time than you thought it would to have your exhibit project completed.

Cost-per-contact and cost-effectiveness of exhibits

The evaluation of your exhibits is really very important. I like to look at the cost-per-contact and cost-effectiveness of exhibits as part of the total evaluation.

Cost-per-contact is how much it costs you each time a visitor used the exhibit over the projected life (usually 5 years or less) of the exhibit. For example, if an exhibit cost $100.00 to build, and over its three-year life only 100 people looked at that exhibit, the cost-per-contact was $1.00.

Cost-effectiveness is looking at what you got in return for your cost/contact. What did you get in return for your exhibit cost? Continuing our example, if you spend $1.00 per visitor contact, did you get $1.00 in benefits from that exhibit (were your objectives accomplished?).

I have seen exhibitions that cost tens and hundreds of thousands of dollars in museums and interpretive centers that visitors hardly even look at or interact with. I have seen some home-made exhibits that cost very little but are very successful in accomplishing their objectives. Having expensive exhibits does not guarantee successful exhibits or cost-effective exhibits.

The visitors and exhibits: more rules of thumb

Over the past 20 years of working with many different exhibit design and build firms, and looking at exhibit evaluation

research, here are some things we have learned:

- Visitors do not really like to read labels. If a label is over 50 words long it probably will not be read. If the label uses small type size (most exhibit labels should be at least 30 point) there is an even greater chance it will not be read. If the label is put on glass, there is even a less chance of it being read.
- Provocative headlines and graphics will draw attention.
- If you can't get the main point or concept of the exhibit across to visitors within 15 seconds, you probably won't get it across at all.
- Visitors will be drawn to exhibits that have information or artifacts of intrinsic interest to them.
- Before you write your label, ask yourself why would a visitor want to read this?.
- The average viewing time for a video or slide presentation within a gallery or in an exhibit is about three minutes before the visitor loses interest and walks away. It will be less time if the visitor doesn't know how long the video or slide presentation is. You need to put a *Press for a … minute video* direction with the presentation if you have any hope of the visitor watching the whole thing.
- The average viewing time for sit-down AV programs in small theaters is about seven minutes before the visitors begin to lose interest.
- If you can't fix it in-house with a screwdriver – don't put it in. This sounds a bit radical, but you would

be surprised at the problems many centers have with repairing expensive exhibits – finding parts, or having staff trained to do the work. If you spent a lot on exhibits and equipment (computers, AV equipment, etc.), it is best to have a service contract with someone who can come in quickly to do repairs.

· Remember Veverka's Law for Exhibit Planning: it will probably cost more than you thought, and take longer than you planned to get your exhibit project done the way you first envisioned it.

· And lastly, remember that you are not your audience! Just because you or your staff likes frogs, birds, historic artifacts, etc. doesn't mean that your visitors share the same feelings or have the same interests. Know your audience!

· Pre-test and evaluate. The only way to really know if your exhibit is successful is to do a pretest to see if your objectives are being accomplished before the final exhibit construction and installation occurs. While this does add cost and time to the total project, do you really want to spend tens of thousands of dollars on something that doesn't work or produces no benefits?

Summary

An interpretive exhibit is a communication media that is designed to engage, excite, relate to, reveal to the visitor the essence of the topic or story being presented. An interpretive exhibit must use interpretive principles (provoke, relate,

reveal, have a theme and message unity), and be built on the learning, behavioral and emotional objectives that will produce the real outcome desired for visitor. An interpretive exhibit doesn't simply present information, but translates information or concepts from the language of the expert to the language of everyday people.

27

Planning Truly Interpretive Panels

Are your boards boring?

If your interpretive boards or panels are boring, then you can be sure of one thing – they are *not* interpretive. Truly interpretive panels are planned and designed to be exciting, provocative, revealing and memorable. There is a big difference between interpretive and informational panels. This chapter will reveal the difference and give you some ideas as to how to make sure that your interpretive panels effectively communicate with you visitors – and accomplish their purpose.

What does it mean to be Interpretive?

Today almost everything we toss out in front of visitors is called interpretive, yet most of the communications we give them are informational not interpretive! The definition of interpretation I prefer to use, and have taught for many years, is:

Interpretation is a communication process designed to reveal meanings and relationships of our cultural and natural heritage, to the public, through first hand involvement with objects, artifacts, landscapes, or sites.

The communication process in the definition is the use of Tilden's *Interpretive Principles* which state that to be interpretive the communication process must:

- Provoke the attention, curiosity or interest of the audience.
- Relate to the everyday life of the viewer or reader.
- Reveal the theme or key point of the message through

a unique or creative viewpoint, design or perspective.
- Address the whole – the interpretation should illustrate a higher theme or message.
- Strive for message unity – use the correct graphics, colors, textures, design elements to support the theme of the interpretive message.

This process is also the basics of a good advertisement. When you look at or read a provocative ad in a magazine or on TV, you are seeing interpretive principles at work. Interpretation has come from, and uses communication strategies and techniques from: advertising, marketing, consumer behavior, psychology of the audience, recreational learning theory, journalism, as well as other support areas.

Planning interpretive panels

Plan for your total site interpretation and your media mix.

Before you begin planning for one or more interpretive panels you should first consider the main story or theme of your total site and other interpretive media and services that will make up your message media mix. What is a media mix? To illustrate and interpret the total site story to your visitors you may use a variety of media including printed leaflets, visitor center exhibits, outdoor demonstrations, living history, guided tours, self-guiding audio devices and interpretive panels. The variety of media you use for interpreting your total site is your media mix.

In the interpretive plan for your total site you should

have determined that for a given site, resource or location, interpretive panels were the best or most cost-effective media for interpretation at that location. But the panel(s) is only one of many different media you may be using to illustrate/ interpret your total site theme. So, you should consider, as good planning practice, where and how the panel will fit into your total media mix presentation of your site story. Is a panel the best media? Do you need an interpretive panel? Remember, you are interpreting the whole site, and a panel(s) for an individual location should be planned and designed to fit into the total site story presentation and design look (media graphic standards). The bottom line – the interpretive panel should fit in and help illustrate your total site interpretive message.

Interpretive panel planning considerations

Once you have decided that an interpretive panel(s) is the best media for interpretation at a particular site or resource, here are the key steps I recommend in planning and designing interpretive panels.

Story and theme analysis: Identify the key concept that this particular panels will be designed to interpret. The best way to determine the theme is to ask yourself: if a visitor only remembers one thing or message from this panel, I want that one thing to be... The answer is the theme. Note that there is a big difference between a theme and a topic. A theme is a complete sentence and a topic isn't. For example:

- Topic: Birds of the park
- Theme: We manage this habitat to attract three species

of migratory birds.

The *theme* is what the panel graphics and text will illustrate.

Audience analysis: Once you have the theme you want the panel to interpret, you also need to consider just who will be reading the panel. Will the audience be: experts or people with little knowledge; local residents or tourists; children or retired folks, etc. The market group that the panel is designed for will translate into the kind of text, graphics, and relate approaches you use in the final design.

What are the objectives of the panel? This is the area where most planning falls short. I would guess that most panels in the countryside today are objective-less panels. That means that no one can explain why they are there other than that, "we got funding for five boards and had to do something!" The *only* way you can be sure that your panels are working are to have objectives for them. I like to use three different objective levels in panel planning:

- Learning objectives: Upon completion of reading/ looking at the panel, the majority of the visitors will be able to list the three ways that wildlife preserves benefits wildlife and people.

- Behavioral objectives: These are the most important of the objectives as they determine the real results or purpose of the panel. For example: upon completion of reading the panel, the majority of the visitors will use this resource in a safe and stewardship-like manner. Or: Upon completion of reading the panel, the majority of

visitors will stay on designated trails only.

· Emotional objectives: These are the objectives where you describe how you want the audience to *feel* upon completion of their interaction with the panel. It is the emotional objectives that drive the Behavioral objectives quite often. Fort example: upon completion of reading the panel, the majority of the visitors will feel that protecting natural areas is important for them and their children. Or: upon completion of reading the panel, the majority of the visitors will feel the desire to help support the (agency, etc.) that manages this preserve.

The true success of the interpretive panel is dependent upon you having clear and accomplishable objectives. How can you plan a panel if you don't know what it is you want the panel to accomplish?

The two questions! After you have developed your objectives, or as you consider what you want the objectives of the panel to be, ask yourself these two questions:

1. Why would the visitor want to know this? This is my who cares? or so what? question. If you cannot answer this questions – you will have a problem in the panel being successful. Be careful not to have your panel giving answers to questions that no one is asking! If you can think of a good reason that the visitors will want to know this information – use that statement as part of the panel header (Provoke). For example: This plant can save your

life! Would you want to know more?

2. How do you want the visitor to *use* the information you are giving them? If you don't want the visitors to use the information on the panel in some way, then why are you giving it to them? The answer to this question can become your behavioral objective(s), such as to: have a safer experience; or to: consider becoming a volunteer at the Centre. Again, there is not a right answer. But you need to consider the question carefully. You have spent a lot of time and money on developing this panel – *why*? What do you want as a result of your panel investment?

5. Determine How/When/Where to use interpretive boards or panels: This planning consideration concerns itself with such issues as selecting the panel materials that would be best for your site/use. Kinds of materials can range from fiberglass and porcelain signs to photo metal, lexan, and other materials. Each sign material has its benefits and limitations. It's good to ask for material specifications and samples from different sign manufactures to see what your options and costs are. Remember, the visitors don't care what kind of panel material you use – they only care about the quality of the message presentation! How/When/Where questions you also need to consider are:

- Panel locations. What kind of mounting system will you need, what will the impact on the panel mount have on the environment or on the view?
- Panel maintenance. Can the panel and mounting

system be easily maintained should any vandalism occur or the panel need to be changed in the future?

- What is the life of the panel – how long do you intend to have it in place as is? The answer to this question might reflect on your choice of panel manufacture materials.
- Will the panel topic be for a seasonal presentation or a year round presentation?
- Will any of the information presented on the panel be likely to change in the near future?

6. *Evaluation:* This is an important step in the interpretive planning process that is almost always left out. Before you spend $2000.00 on a panel or board, wouldn't you like to be sure that it works (that its objectives are being accomplished)? I recommend that you make a simple photo copy of the proposed draft panel and pre-test it with a sample of your visitors to see if they understand the message, etc. When you have the panel text and graphics working at a 70% of greater level of objective accomplishment – then send it out for final production.

7. *Implementation and Operations:* This part of the planning process focuses on the real costs, time and logistics involved in getting from the "let's have a panel" stage to the final installed product. Some of the questions you need to consider include:

- What is the budget, and what are our media fabrication options for that budget.

- When do we need it by, and how long does it take from plan to fabrication?
- Who will do the contract, manage the contract, etc.
- Who will do the research, write the label copy, select graphics, do final design, and do the actual fabrication?
- Who is responsible for approvals (drafts, text, design, etc.)?
- Who (will you) do any pre-testing evaluation studies?
- Who will install the panel(s) and maintain them?

Remember the visitor!

In planning and designing interpretive panels it is important to remember some basics about how visitors learn and remember information:

- People learn better when they're actively involved in the learning process.
- People learn better when they're using as many senses as possible.

Make sure that the visitors use the panel to help them look at and understand the resource the panel is interpreting. Use behavioral considerations in the panel design and text such as: *Look for the...*; or *can you find the... in the site in front of you?*; *Go ahead and touch the...*; *Listen for the...* These action steps will help design some minds-on and hands-on activities for the 90% of what they do communication information retention process.

Dare to be *creative*!

If you have had some time to go out and look at interpretive panels you might have noticed some things that many have in common. They might be uninviting, unexciting, unmemorable, and probably unsuccessful! How many of the panels you have seen in the past can your remember anything about? Do you want your panels to be the same? Do you really want to spend $1000 or more for your panels message to be a blur in your visitors site experience? Then dare to be creative!

Depending on the particular panel topic: consider using cartoons; use hidden picture graphics (how many birds can you find in the illustration?); challenge the visitor to look for, find, smell, touch, *think*; use riddles or puzzles and have the visitor check with staff, at a visitor center, etc. to see if they had the correct answer. Consider using a 3D panel – using sandblasted wood to create an elegant presentation of shape, color and text. Design a vertical panel with a peephole so the visitor can look through the panel to see a resource. Use clear vertical panels with sand-blasted historic illustrations on it so that a visitor can look at/through the panel at the historic site and see superimposed on the site, through the clear-etched panel, what the resource might have looked like 100 years ago – 500 years ago! Dare to be creative!

Other creative ideas?
Use the panel mounting or frame as an exhibit element too! You can use solar powered digital sound boxes in the frames to include bird calls, sound effects or other messages; or use 3D fiberglass impressions built into the frames for visitors to

touch.

Don't be so comfortable with the way that it has always been done. There is not a wealth of evidence showing that the way we've always done it has actually worked! Try new ways, new strategies, and new perspectives. And pre-test before you build. The visitors should be the ones to tell you if it is a good idea or not.

What if it fails?

A ship in port is safe, but that's not what ships are built for.
- Grace Hopper, Inventor.

There's as much risk in doing it the way it's always been done as there is in trying something new.
- John Veverka, Interpretive Planner.

Behold the turtle who makes progress only when he sticks his neck out.
- Old Chinese proverb.

The point to all this is that there are lots of new, exciting and creative ways to tell a story with a panel. You shouldn't feel restricted in your individual creativity – it may be just the thing needed to help make an potentially boring story really come to life for the visitor. Remember, the chief aim of interpretation is provocation – *not* instruction.

Summary

This chapter focused on the key components to planning and designing a successful interpretive panel. The planning process should consider:

1. the main theme of the panel;
2. the intended audience;
3. the objectives of the panel;
4. how/when/ and where you intend to use the panel;
5. how you will evaluate the panel to make sure that its objectives are being accomplished;
6. and implementation and operations considerations.

Interpretive panels must use interpretive principles: provoke, relate and reveal the essence of the message. And finally, consider the visitor, they are not out on a holiday to read a book on a stick. Make sure that the panel content relates to them and considers the two questions: *Why would the visitor want to know this?* and *How do I want the visitor to use the information I am interpreting to them?*

Interpretive panels don't just happen, they are carefully planned. For the time and investment involved producing them, interpretive panels are more effective than panels not using interpretive techniques or principals. Their product is your success – if done correctly.

GRAPHICS

28

Interpretive Graphic Standards: Recommended Interpretive Standards For Interpretive and Heritage Sites and Attractions

The function of an interpretive sign or panel is to communicate specific educational and/or management learning, behavioral and emotional messages to visitors. Interpretive signs are most commonly used for self-guiding trails, or for wayside exhibits at points of interest such as viewing areas, resource management areas, or visitor information kiosks.

As interpretive signs will vary greatly in content and design, this Interpretive Graphics Manual will focus on interpretive planning and writing guidelines and format suggestions.

It is not the intent of this chapter to control the visual look of the finished interpretive panel; rather, the intent is to provide guidance in developing interpretive signs. Interpretive signs need to reflect creativity and flexibility, as they relate to specific sites, goals, and objectives.

Interpretive signs are to be used for interpretive purposes, and not to be used to circumvent requirements for approval of, or as a replacement for, caution, danger, warning, or other management signs. Interpretive signs may be used to help make the public aware about management issues and their responsibility/safety when using these resources.

What does it mean to be interpretive?
Today almost everything we toss out in front of visitors is called interpretive, yet most of the communications we give them are informational not interpretive! The definition of interpretation I prefer to use, and have taught for many years, is:

Interpretation is a communication process designed to reveal meanings and relationships of our cultural and natural

heritage, to the public, through first hand involvement with objects, artifacts, landscapes, or sites.

The communication process in the definition is the use of Tilden's *Interpretive Principles* which state that to be interpretive the communication process must:

- Provoke the attention, curiosity or interest of the audience.
- Relate to the everyday life of the viewer or reader.
- Reveal the theme or key point of the message through a unique or creative viewpoint, design or perspective.
- Address the whole – the interpretation should illustrate a higher theme or message.
- Strive for message unity – use the correct graphics, colors, textures, design elements to support the theme of the interpretive message.

This process is also the basics of a good advertisement. When you look at or read a provocative ad in a magazine or on TV, you are seeing interpretive principles at work. Interpretation has come from, and uses communication strategies and techniques from: advertising, marketing, consumer behavior, psychology of the audience, recreational learning theory, journalism, as well as other support areas.

General interpretive panel graphic guidelines
Point size: This means the size of the text you will use on the panel. Here are some sample point sizes for illustration:

This is 12 point type.

This is 14 point type.

This is 20 point type.

This is 28 point type.

A lot of research has been conducted by the US National Park Service, and other agencies that use thousands of interpretive panels. The research recommends that the smallest type size to be used on interpretive panels is 28 – 30 point. It has been learned that this is the minimum size that is easiest for visitors to read while standing between 3-5 feet away from the interpretive panel. A visitor should never have to bend down to read an interpretive panel!

Font design: This is the shape of the letters you can use. As you know, most computers have lots of different fonts. For example this font is called Dolly. Here are some other fonts that are recommended to be used on interpretive panels. Again these has been researched for the fonts that are easiest for visitors to read, but you are free to try others. If you not sure – test them with your visitors, at about 30 point size, to see which they find easiest to read:

This is Times New Roman

This is Verdana

This is Palatino

This is Rockwell

This is Arial Black

You can also use colors and different fonts to illustrate a point or theme in your interpretive panel. For example:

- You can bold in the first part of a sentence to attract visitors to some key part of the message (provoke).
- You can use color to illustrate a point.
- You can bold in key words that you want visitors to focus on or when introducing new vocabulary words such as **habitats**.
- You can use different fonts to illustrate points such as *FAST* vs. fast (note the letters are tipping), or **HEAVY** vs. HEAVY.

Amount of text for interpretive panels: As a general rule of thumb, again coming from research on readability for interpretive panels, we know that interpretive panels should not have more than 100 words (about two 50 word paragraphs). Within these guidelines, it is recommended that the first sentence of each paragraph be bold to attract the visitor's attention to what the paragraph/text is about (like newspaper headlines).

Mounting angles: In general interpretive panels would be mounted at about a 45 degree angle. This is the easiest angle for visitors to read at.

Frames and mountings: Remember that your panel will need to be held up by a framing system. Frames can vary widely in

Figure 1: here is a draft interpretive panel for a watchable wildlife area. While it may not look like a draft, it was done a computer using Microsoft Word. Text boxes were used to insert the header, photos of eyes, lower text box and finally a text box for the photo (inserted as a jpeg). This draft can be printed off for pre-testing and making any corrections. Then e-mailed to a designer for any final touch-ups and to make sure the layout is correct for enlarging this mock-up to a large interpretive panel.

design, shape and materials, from metal to wood, from angular to vertical. You need to think about which framing system and materials would work best for you.

Developing draft designs for your interpretive panels

It is generally recommended that you first develop a draft design and text of what you want your panel to look like, based on your learning, behavioral and emotional objectives, and using Tilden's Tips of Provoke, Relate and Reveal. This gives you a chance to think about your audience, final sign placement, vandalism issues, and content. You can also pre-

test your draft designs with your visitors before going to a designer for the final design/layout and artwork – then being sent to a company to have the panel manufactures.

Fig 1. shows an samples of a draft or mock-up interpretive panel from an interpretive panel design workshop, to give you an idea of how a mock-up interpretive panel might look.

Trail head signs

Self-guiding interpretive trails use two different types of signs: one large trail orientation sign (called a trail head sign) and several smaller trail stop/station signs located at various stops along the trail.

The role of the trail orientation sign at the beginning of the interpretive trail is to give the visitor a general overview of what the trail is about and what kinds of experiences to expect. Based on this information, the visitors can decide whether or not to walk the trail. Every trail orientation sign should include:

· The name of the trail.
· A brief introduction to the theme of the trail.
· Walking distance and time. Note: for most visitors the walking time is the most important element to present.
· A trail map so visitors can see where the trail ends.
· Any necessary safety information (i.e. sturdy hiking shoes recommended, steep hills, etc.).

The general size for a trail head sign is about 24" x 36", but sizes and shapes can vary widely as illustrated (Figs. 2-3).

Figure 2: A trail head sign

Designing interpretive panels

As presented earlier, there are a variety of recommendations in developing interpretive panels. Here are some rules of thumb and examples of some best practice in interpretive panel design and writing.

1. Design the interpretive panel (size, colors, and shapes) to fit the landscape and/or location where it will be positioned.

2. Design the interpretive panel to accomplish specific objectives (learn, feel, do).

3. Develop the design, content and text using Tilden's Interpretive Principles (Provoke, Relate, reveal, address the whole and message unity).

4. Keep it *simple*. One graphic that *clearly* illustrates the concept and about 100 words of text.

5. If you can't get your concept across in 15 seconds, you probably won't.

6. Pre-test your design and copy. While a picture might be

Figure 3: This trail head sign from Barton Broad uses a variety of innovative designs including raised illustrations on the sand-blasted wood frame. It is well-written using interpretive techniques, and a design standard that matches the rest of the interpretive panels located along the trail.

worth 1000 words, they could be the wrong 1000 words!

7. Remember to have the visitor *do* something with the panel interpretation (look for the... smell the... can you find the... touch the...)

8. Keep your sentences short.

9. Avoid using technical or unfamiliar terms or vocabulary unless you illustrate the new vocabulary word for the visitor.

10. Use active verbs.

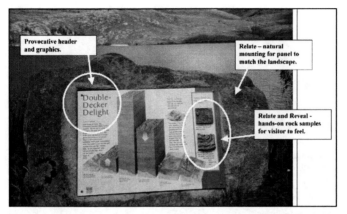

Figure 4: In this example notice how the panel header and graphic pulls you in. The hands-on attachment of rock samples adds that experience bonus to the panel. The provocation elements of header and design encourage the visitor to read the copy, which also is written in an interpretive manner. *Photo courtesy of Scottish Natural Heritage.*

11. Add touches of humanity. Use first person quotations, make references to people's common experiences, and write with warmth and emotion.

12. Encourage visitor involvement (emotional or behavioral objectives).

13. Use colorful language (metaphors, puns, quotations, etc.).

14. Make the interpretive panel contact with the visitor enjoyable so they will be drawn to look for other panels.

15. If the panel is boring it is *not* interpretive!

If you remember 50% of what you see, here are a variety of interpretive panels that we feel illustrate the main points presented in this graphic standards document. Feel free to add your own examples you may see when you visit other

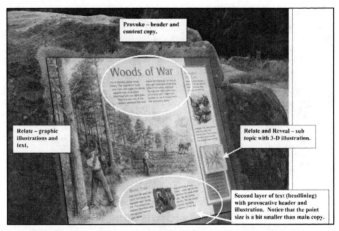

Figure 5: In this example notice how the panel header and graphic pulls you in. The hands-on attachment of rock samples adds that experience bonus to the panel. The provocation elements of header and design encourage the visitor to read the copy, which also is written in an interpretive manner. *Photo courtesy of Scottish Natural Heritage.*

interpretive sites to add to this collection.

Three following examples (Figs. 7-9) illustrate the main concepts of Tilden's Principles of Provoke, Relate and Reveal. They are part of the self-guiding interpretive boardwalk at Barton Broad. Notice how the snail drawing (Fig. 7) accomplishes both the requirement for Relate and Reveal at the same time.

Figure 6: This is a good illustration of fitting the mounting of the panel into the landscape. Notice how the shape of the rock mounting is similar to the mountain being interpreted by the panel.

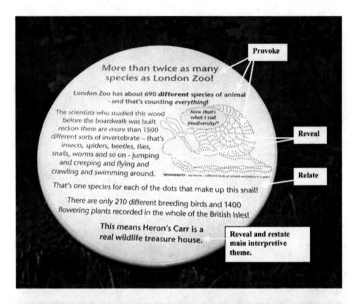

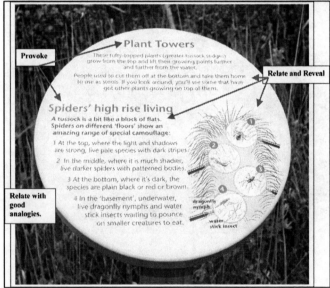

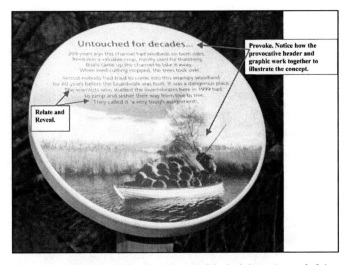

TOP LEFT Figure 7: Notice how the snail drawing accomplishes both the requirement for Relate and Reveal at the same time.

BOTTOM LEFT Figure 8: Barton Broad self-guiding boardwalk.

ABOVE Figure 9: Barton Broad self-guiding boardwalk.

Interpretive Panel Planning Worksheet

Project:

Panel #:
Theme or Topics:
Panel Header (Provoke):

Main Concept to be interpreted:

Panel Location:

Panel Objectives:

Learning Objectives:

Behavioral Objectives:

Emotional Objectives:

Audience (vandalism issues?)

Panel Materials and specifications (size, shape, etc.)

Maintenance issues:

Framing System:

Panel add on interpretive elements
 (3D attachments, audio devices, activities):

Warranty (yes, no):

Evaluation Pre-test:

Figure 10: Interpretive panel planning worksheet

Interpretive Panel Planning Worksheet [2]

Panel Design Checklist:

_____ Provocative header

_____ Provocative graphic

_____ Text in 30 point size or larger

_____ Use headline effect – larger for main copy, smaller for
 secondary copy.

_____ Text around 100 words or less.

_____ Use of Provoke in text.

_____ Use of Relate in text.

_____ Use of Reveal in Text.

_____ Used simple language, analogies, metaphors, etc.

_____ Warranty

_____ Framing System

_____ Appropriate for its landscape location.

MARKETING

29

Marketing Basics:
It's All About The Visitors

Without a doubt, marketing is one of the most critical aspects of any heritage or interpretive attraction's operations. Marketing brings in visitors – and gets them to come back for return visits. Successful marketing efforts = staying in business for most heritage attractions, particularly those not totally supported by local governments or other governmental agencies. But one of the most surprising things to me is, given how critical a professional understanding of basic marketing principals are for any heritage attraction, the lack of understanding of what marketing actually is and how to do it that exists through out the heritage tourism industry. One example of this that I see often involves marketing brochures. During frequent marketing courses, I make the statement to the participants that they have probably spent thousands or tens of thousands of dollars in the design, production and distribution of marketing brochures (the kind you see at every tourist information center), and yet they have no proof that they work! How do you know that these pieces have made any money for you – that they actually brought in enough new visitors to pay for the printing and distribution costs of the piece themselves? This usually generates an audible *gulp* from the audience, as most heritage attractions don't have a clue if their marketing materials and efforts actually work – no tracking or evaluation process. This is particularly common with medium and smaller-sized heritage attractions.

What is marketing anyway?

We spend our lives seeing so much of it, television, radio, web

sites, etc. We are surrounded by it. Marketing is like the word ecology – a nice word, but most people have never seen an ecology. So let's use a working definition of marketing:

Marketing is the process of planning and executing the conception, pricing, promotion, and distribution of ideas, goods, and services to create exchanges that will satisfy individual and organizational objectives. – (From Introduction to Marketing by M. Cooper and C. Madden).

In simple terms, heritage tourism related marketing is successfully communicating with and convincing potential visitors that you have something that they need or will benefit from, and that you can provide a service or fill that need better than anyone else.

And where is the visitor in all of this? Everywhere!
Another aspect of marketing problems is that many heritage organizations and attractions have little or no visitor-based information to work from. They don't know who their markets are! Marketing is all about completely understanding your audience (current, or intended). So in reality, many marketing pieces, from brochures to advertisements in magazines, fail due to a general lack of understanding about their intended visitors and the psychology of the visitors. Brochures often simply illustrate or promote the wrong things. For example, a hotel or motel brochure may show nice photos of the bedrooms or dining area, but what a visitor may really want to know is if that hotel or motel is near any attractions or other services.

Developing a marketing plan followed by marketing materials such as brochures or print advertisements, requires that we know the answers to some (all?) of the following questions about our visitors.

Existing markets for our sites or attractions
- Where are our visitors coming from?
- What are their age groups and other socio-economic backgrounds?
- How long does the average visit last?
- Is there a visitor perception that the admission fee was good value for the experience paid for, or do they think they paid too much for to little?
- What did they spend money on – and how much?
- What were the attraction visit components (shopping, food service, interpretive experiences, social interactions, recreation opportunities, etc.) of most importance to the visitors?
- What were/are their seasonal visitation patterns and influences?
- Why did they decide to visit the site or attraction in the first place?
- What experiences or recreational learning opportunities were they looking for?
- Did the site/attraction meet or exceed their expectations of what they would see-do-and experience here or did it fall short of the visitors' expectations (from marketing brochures and related advertising)?

- What were their best or most powerful memories of their visit?
- What reasons did we give them to return again to this attraction?
- What is the attraction's physical and psychological carrying capacity and did we exceed it? Were we too successful in attracting visitors and couldn't give visitors a quality experience because of too many visitors?
- Could our support services handle our visitor load?
- Was our on-site experience (the visit) as good in reality as our marketing pieces made it look?
- Did our customer care plan/training pay off – did the visitor feel welcome?

These are some of the questions that need to be asked and answered in developing a marketing plan, and marketing materials for current visitors or market groups.

Market creation: generating new market groups

The next aspect of developing heritage tourism/attraction marketing plans and materials is the issue of market creation. This is the answer to the question I often ask clients: we know who your visitors are – but who do you want your visitors to be? Market creation is generating new visitors or market groups to come to your site. For example: more school groups; more local visitors or community residents; special interest groups such as photographers, bird watchers, historical

architecture buffs, railroad buffs; more retired visitors, etc. Here are some of the questions to be answered in developing marketing strategies and materials for these potential visitors (market groups):

- What specific new target markets would be interested in the stories, materials, experiences, artifacts, etc. that our site offers?
- What would we promote as the benefits for these new market groups to coming to our attraction? What's in it for them by coming to our attraction?
- Would these be seasonal market groups? If so, which seasons?
- How do we contact these new market groups (advertisements in specialty magazines or publications, mail outs to clubs and organizations, emails to specialty organizations membership lists, etc.)?
- Do we have the support services in place to handle a surge in visitation (parking, staff, food service, volunteers, etc.) if they show up?
- How do we design and structure our advertising materials to get the attention of, and relate to these new market groups? Do our marketing materials have photos with people in them? Are there photos of our intended market groups in our marketing pieces? What are the people in our marketing piece photos doing?
- How will we track and evaluate the success of our

market creation plan?

- Will we need to do some site re-design or additions for these new market groups (such as adding baby changing stations in restrooms if we are trying to attract families with very young children)?
- Are these new market groups renewable (want to come to the attraction more than once) or are they one-time visitors only (as the market groups might be for attractions located along interstate highways)?
- How have other attractions done that cater to or try to attract these same market groups? What has been the key to their marketing success? Were they successful?

You can see that there is overlap in considering these questions, as you may be marketing to both groups (current visitors as well as trying to attract new or different market groups) at the same time. The question arises as to how you can do any real marketing efforts at all without knowing the answers to most of these questions? This is why some existing marketing pieces can look great but not work. They may be giving answers to questions that your main market groups aren't asking, and not answering the questions that they are asking. And no one knows this is going on.

What should be in a marketing plan for heritage attractions? Here is a general outline I use when developing or teaching courses in Heritage Tourism Marketing. Feel free to add or modify this outline to suit your specific needs:

Marketing Plan Basic Outline for Heritage Tourism Sites and Attractions

Objectives
(what do you want this plan to accomplish?)
Learning objectives
Emotional objectives
Behavioral objectives

Product(s) analysis
(what are you selling?)
Experiences (experience and memory mapping and analysis)
Passive experiences
Active experiences
Psychological immersion
Physical immersion
The experience mix

Physical products
(books, trail guides, guided tours, videos, etc.)

Current market groups (macro and micro) analysis
(Who are your current visitors, where are they coming from, etc.)
Current visitor demographics (any existing research available?)
Seasonal visitation patterns
Visitor expectations and motivations for visiting your site
Customer care needs (handicap accessibility, food service, etc.)
Market mix sustainability (school groups, out of country

tourists, etc.)
Visitation patterns (increase or loss) over the past 5 years

Critique of current marketing/advertising strategies
(do the work – how do you know?)
Current advertising plans and ad placements (what magazines,
etc. and why)
Current brochure and brochure distribution
Other advertising materials

Market income stream
Cost-per-contact
Cost-effectiveness
% of total budget from admissions and gift shop sales, etc.

Competition analysis
Other nearby similar attractions or sites with similar services
and experiences
Other attractions in your area (their visitation numbers,
seasonal visitation patterns, target market groups, etc.)
Potential for developing partnerships (joint admission tickets,
etc.?) with nearby attractions?

Market creation
Which new market groups do you want to try to attract?
What benefits can you offer them by visiting your site or
attraction?
What promotion or advertising strategies will you need to

communicate with them and tell them about your site and services?

Where and how to make the most powerful first contacts

Marketing campaign
Budget allocations based on need
Advertising material design and pre-testing
Ad placements and tracking strategy
Web site development

Advertising strategy
(consolidated from other sections above)
What, when where, media selections, costs, etc.
Ad mix designs and pre-testing

Implementation of the marketing plan
Timelines for implementation
Budget determinations per ad line item
Staffing needs
Contracting needs

Tracking and evaluation of the ad campaign
(Ongoing evaluation to see how the advertising is going month by month)
Tracking reviews (schedule, etc.)
Evaluation tools, and on-going evaluation (monthly?)

Again, this is a general content outline for a complete

marketing plan. Feel free to add or change this as best fits your particular needs.

New theories and concepts to be thinking about when developing your marketing plans and strategies

A lot of new and exciting theories and practices have emerged that greatly affect how we do heritage tourism planning and marketing. Some of these ideas and concepts include:

- Markets of one
- Mass customization

These concepts involve learning how to mass produce yet individually customize goods or services, with major implications for heritage tourism planning and marketing, particularly for large heritage interpretation areas and heritage corridors, but also for helping to plan programs and services at museums, parks, historic sites and related attractions.

Experiential marketing

What visitors are looking for are experiences – this is a key concept in developing and marketing for any heritage/ interpretive attraction. What experiences does your attraction offer – how powerful are the experiences? How memorable? Marketing pieces need to illustrate the kinds of or range of experiences your site offers. Check out the reference listing of this chapter for good books on experience marketing.

Memory mapping

When I do interpretive master planning for heritage/ interpretive sites and attractions I now look for (and plan for) where the best and most powerful memories of the visit will come from (or need to be created). Where will visitors want to have a photo taken of them standing next to? What will they take pictures of? What do you want them talking about in the car on their way home from visiting your site? What memories (souvenirs) enhancements will you have available (post cards, T-shirts, videos, photo opportunities)? Why do you think Disney goes out of their way to make sure you and your children can have photos taken with the various Disney characters when you visit Disney World?

These are just a few of the new heritage tourism/ interpretation marketing ideas that we are now using in developing marketing plans and marketing materials.

Don't even think of not pre-testing your marketing materials! Finally, when you have competed your thought process and answered all of the questions about your audience, and designed your various marketing pieces, there is only one person(s) who you should ask to see what they think of them – the people the marketing pieces were planed for. They will tell you, through pre-testing of the materials, if they like or understand them. This evaluation process is very important – why would you want to spend thousands of dollars on something if you have no proof that it works? Remember:

- Don't just ask the people who designed the marketing

pieces if the brochures or ads are good or will be successful (guess what the answer will be).

- Don't just ask your staff members if the marketing pieces are good or will be successful – they have no way of knowing.
- Don't just ask the Board of Directors what they think (that will take forever and they won't know if the pieces will be successful either).

The only reliable people to ask if the marketing pieces are good, or have any chance of generating a visit are the potential visitors the marketing pieces were intended for. Ask them! Then and only then will you know for sure if the marketing materials and communication approaches really do connect with those visitors.

Summary

It was the goal of this chapter to give individuals involved with the marketing of interpretive/heritage tourism sites and attractions some things to think about when developing a marketing plan, and particularly in developing marketing materials. The main point is to remember that everything involving marketing is about the visitor. If your marketing materials don't connect with them, the visitors won't show up at your attraction. Marketing is something that requires a level of professional understanding about it, and a deep understanding of such topic areas as:

- The psychology of the audience.

- Visitor motivation and expectations.
- Recreational learning theory.
- Consumer behavior.
- Interpretive communications.
- Psychology of interpretive design
- Marketing research techniques.

With the ultimate success of most heritage attractions centered on how that attraction is marketed – it is well worth the investment in time and staff to do it right the first time.

References

Cooper, Marjorie J. and Charles Madden. 1993. *Introduction to Marketing*. Harper Perennial, NY.

Gilmore, James H. and B. Joseph Pine II. 1988. Markets of One. *Harvard Business Review*, Boston, MA.

Gottdiener, Mark. 1997, *The Theming of America*. Westview Press, Boulder, CO.

O'Sullivan, Ellen, and Kathy Spangler, 1998. *Experience Marketing - strategies for the new millennium*. Venture Publishing, State College, PA.

Pine, Joseph B. II. 1993. *Mass Customization*. Harvard Business School Press, Boston, MA.

Pine, Joseph B. II and James H. Gilmore. 1999. *The Experience Economy*. Harvard Business School Press, Boston, MA.

Schmitt, Bernd H. 1999. *Experiential Marketing - how to get customers to Sense-Feel-Think-Act-Relate to your company and brands*. The Free Press, NY.

Veverka, John A. 2000. *Interpretive Planning for the New Millennium: Outcome and experience-based planning strategies*. Legacy, Volume 11, Number 3, May/June 2000.

30

A Practical Guide To
Developing Marketing Brochures

Do the brochures at Fig. 1 get your attention?

If it is to be a successful marketing piece it better! There is more to developing a successful interpretive or marketing brochure than you might think. The planning process begins with first impressions, and works its way through content, colors, photos, and more. It involves a real understanding of the psychology of the audience, and in understanding what they might be looking for in a heritage attraction.

This chapter is designed to give you an overview of some of the key considerations in developing successful marketing brochures. Not that you may be the designer yourself, but you must be an informed consumer. I will give you a checklist of things to consider in developing your market pieces, and how to help your designers create successful and market friendly brochures.

Developing your theme

The planning model I use for developing interpretive brochures (or any interpretive product) begins with the story. What is the topic or message that I need to present and what is the *theme* that the piece needs to illustrate. A theme is a complete sentence that captures the essence of the total site story. The theme for the brochure above seems to be that The Polynesian Cultural Center is Hawaii's favorite visitor attraction. The content of the brochure then continues on the inside to illustrate to the reader why this statement is true.

Take a look at the next brochure. Can you tell what the main theme (or tourist story presentation) might be? Who is

Figure 1: Do these brochures get your attention ?

Figure 2

the audience – what are the products (experiences) they are marketing?

This is one of my favorite heritage tourism marketing brochure covers (Fig. 2). It does several things. First, it clearly states what the main theme of this attraction is: At Highland Mysteryworld you will see (Scotland's) legends come alive. This theme statement is very well illustrated by the photos on the cover (powerful first impressions) and also helps define the target markets for

this attraction. We will talk more about target markets a little later on.

This is a good place to remind the brochure designer that in many cases only the top third of the actual brochure is visible in most typical brochure rack displays, for this particular brochure that would be just below the purple band right below come alive. So for most purposes, this is a great example of theme presentation (plus a lot of other marketing concepts)

Figure 3

The brochure in Fig. 3 was designed to look like a bundle of old bank notes, with the brochure header to look like a bank currency wrapper. And with Canada being a bilingual country, the brochure has an English text on one side, and a French text on the other side. This is a good example of theme design presentation.

Developing your brochure objectives

The next step in our planning process is too clearly identify exactly *what* you want the brochure to accomplish - what are your objectives. I have found that many (most) marketing brochures weren't planned with objectives - they were just jammed with information. I use three kinds of objectives in my planning process. And remember that objectives are measurable.

Learning objectives: With these objectives I like to quantify the kinds of information that the brochure will present. For example: Upon reading the brochure, the majority of tourist will be able to:

- List three benefits they will gain from visiting my attraction.
- Describe the main facilities that we have available for them.
- Understand our hours of operation, admission costs and services.

With these objectives listed the designer knows what content (and photos) will be required to accomplish (or illustrate) these points.

Emotional objectives: In marketing, these are the most important. These are the objectives that will make a visitor feel that this will be a great experience – that I can't miss this!, or that: this site or facility will be easy to get to – no trip stress. Emotional objectives are accomplished mostly with the photos you select. Take a close look at the two brochure covers – what emotions do they convey?

Behavioral objectives: For your attraction these are the most important objectives. These are the actions or behaviors you want the potential tourist to do. Here are some examples:

- Potential tourists will come and visit our attraction.
- Tourists will go on our tours, eat their lunch at our site, buy souvenirs.
- Tourists will tell others about our attractions.

- Tourists will return for other visits.

The behavioral objectives will (might) be accomplished if the other emotional and learning objectives do their job.

Who?

The next step in the planning process is to clearly determine just who your attraction or site target markets are. Here are some examples of typical target markets.

- Families on holiday with young children.
- Families on holiday with older children and teens.
- Families from the local community (high return visits).
- Foreign tourists.
- Older visitors (retired or with no children in the household).
- Retired individuals coming to your site by bus (coach tours).
- General tourists coming to your site by coach tour.
- School groups
- Tourists with special hobbies or interests (wildlife watching, hiking, skiing, visiting historic homes, etc.
- Special groups or tours.

Of course these target markets can be further broken down into sub groups, but this gives you the idea. Your site or attraction will have a specific target market mix (year-round or seasonal) that are most likely to want to visit your kind of facility or attraction. Understanding this market mix helps you

to identify:

- What photos to use in the brochure (you better have photos of the kinds of market groups that you are trying to attract)?
- How your distribute your brochures.
- What kinds of services, events, or activities these market groups may be looking for?

What market groups do you think the attractions shown at Fig. 4 are most interested in?

Figure 4

These two sites have a clear idea of the target markets that they are trying to attract as their main market group, and effectively used the cover to clarify this for potential visitors.

Can you tell what the emotional objectives of the cover design might be? Is there a theme statement as to what the attraction is about? What are the benefits or experiences they are marketing – the reasons for visitors to show up?

The interior of the brochure also needs to follow through with this consideration of market groups and emotional objective illustrations. The brochure interior below (Fig. 5) does a nice job of illustrating experiences visitors can do on site (only about a third of the total interior is shown here).

Figure 5

Once you have a good idea of your theme or story presentation needs, you have clearly outlined your learning, emotional and behavioral objectives for the brochure, and have

focused on the target markets your site is best suited for, or that your want to work on attracting, the next step is in the mechanics of putting this plan into action.

The checklist (the to do list) for planning and designing successful heritage tourism and interpretive brochures
First impressions – the cover:

- Can you tell within 5-10 seconds what the subject of this leaflet (attraction) is?
- Can you well within 5-10 seconds who the intended market group(s) is?
- Can you tell within 5-10 seconds what the site offers the visitor or market group?
- Does the brochure header/design provoke attention or interest?
- Does the leaflet give you a general *Oh my – this looks interesting!* feeling?
- Does there appear to be benefits to the market group – reasons to pick up and look at the brochure in more detail (open it up)?

Leaflet/brochure planning

- Are the objectives of the brochure clear (to you and the audience)?
- What information do you want your market groups to learn?
- How do you want them to feel about your site or attraction?

- What do you want the market group to do as a result of reading your publication?
- Does the publication have a clear theme or central marketing message?
- Is your target audience clearly defined (who is in the pictures you are using)?
- How will you distribute your publication (this affects design, paperweight, etc.)?
- Mail out to potential visitors.
- Distribution via brochure rack. Remember that in most cases only the top third of the brochure will show.

These three attractions (Fig. 6) use the top third effectively to convey who they are. Cover up bottom two-thirds of your current brochure if you have one. What does the top third convey to your visitors?

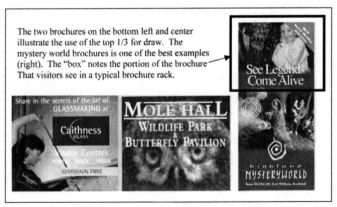

The two brochures on the bottom left and center illustrate the use of the top 1/3 for draw. The mystery world brochures is one of the best examples (right). The "box" notes the portion of the brochure That visitors see in a typical brochure rack.

Figure 6

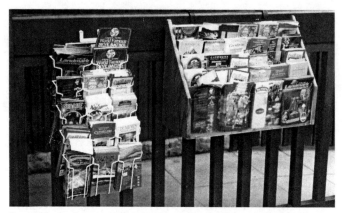

Figure 7: Your brochure can easily get lost in a sea of brochures if you are not careful. The effective use of the top third becomes more important when you consider where and how your final product will be made available to the public.

How will you evaluate the success of your publication (know that your stated objectives are being accomplished)?

- You can pre-test draft brochures with test groups (some of your current visitors).
- Do response evaluation of your current brochures.
- Do audience observations at dispersal points.
- Analysis by an expert.
- Other evaluation methods.

The important thing to remember is to find out if the brochure is successfully conveying the messages you want before you print and distribute thousands of them!

Brochure design mechanics

Point size: Point size is the size of type you are using for your

brochure. You want to use as large a point size as you can. This may mean you have to edit your copy to get it to fit with a larger type.

- Is the point size used for your brochure appropriate for the target audience (i.e. if it is to small, older visitors may have trouble reading it)?
- Get some examples of other brochures to look at (and learn from). What point size are they using – can you easily read the copy?

*Font:*You want to select the right font to go with the correct message illustration. Your designer can help with this too.

Some things to consider:

- Is the font easy to read? Would you want the total text in Antique Olive?
- Does it support the theme (old font types for historic site brochures, more modern fonts for science museums, etc.)?
- Are a variety of fonts used (and why)?
- What color should the font be printed in – do I need to have text in colors?

Brochure folds: Another thing to consider is how you want your brochure folded. Here are some things to consider:

- Is the design best suited for a open (no folds) or multiple folds (like a road map)?
- For larger publications, can the user easily re-fold the publication?

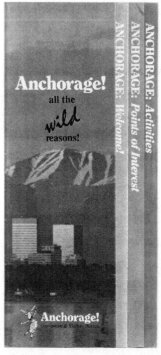

Figure 8

· Is the fold part of the overall design – help define topic areas?

Fig. 8 is an example of a more elaborate brochure fold. Each of the three subject areas on the right open to a different information page, with additional folds to each of those pages. Remember that you are paying your printer for each fold. Some printers may only charge a few cents per fold, but with thousands of brochures to be folded, this can add up!

Paper selection: Another important area to consider is that of what kind of paper should we use to print our brochure on? Here are more things to consider:

- Does the paper type used support the message/theme of the brochure?
- What color paper should you use? Remember if you print photographs on color paper, the white parts of the photo will now become the color of the paper and can really ruin a photograph.
- What paperweight will you use? This has an impact if

Figure 9

your brochure will be used in a brochure rack.

Notice in Fig. 9 how many of the brochures and leaflets are, what I like to call, weeping. They were printed on a lighter weight paper, and when exposed to the elements (wind, humidity, etc.), bend over in this outdoor rack. The same will happen indoors too. So for display rack use you may want to consider a stronger (heavier weight) paper to print them on.

Talk to your printer about paperweights and have them show you examples. This might help make your planning job easier.

Paper texture: Like with the weight of paper, paper also comes in different textures. This can run from enamel paper, like most color brochures are printed on, to special papers with lots of textures (fibers) in them. Again, a printer can show you lots of different kinds of papers to select from.

Paper finish: This is part of the paper texture selection, but needs to be considered. Remember that if you are designing a brochure for outdoor use, like a site map or a walking tour, enamel papers (with shiny finishes) reflect sunlight, and may be very hard to read outdoors. You may want a flat finish (non-

Figure 10

glare) paper for outdoor use.

· Does your type of paper then support the publications intended use?

· Non-glare for most outdoor use.

· Heavier weight paper for outdoor use (won't bend or blow easily in the wind).

· Lighter papers for mail outs or bulk mailings.

· Does the brochure use unique or interesting die cuts to attract or focus the potential tourist's attention?

· Die cuts are an expensive brochure treatment, but can add to the attraction power of the piece. A die cut is most simply, a cookie cutter for the paper that cuts out designs. Here is a good example from St. Andrews Sea-Life Center in Scotland (Fig. 10).

The Sea-life Centre (Fig. 11) brochure uses several die cuts. One for the large hole in the center of the brochure right below the seal. When you open the brochure you can see the die cut. The next die cut is the top border, directly above the seal (top left in the open brochure).

This particular brochure uses several more die cuts very

Figure 11

effectively as you open the brochure more. Again, die cuts can add to the expense of brochure publication, but can also help in attraction power of the brochure as this one does.

Publication copy/text

Copy or text presentation is also an important part of the overall brochure design. To much text (or all text) can overwhelm the potential visitor. Remember – they are not on holiday to read lots of stuff. A good example of text or copy presentation is shown at Fig. 12.

Notice that the copy does not overwhelm the layout. In particular, look at the use of bullets to highlight information about the site, and the different point sized used. I also like the use of captions with the photos. Again, not too much text, just enough to let me know what I am looking at.

Figure 12

Here are some things to consider about your publications' use of text:

- Is the copy written in short, provocative paragraphs?
- Does the copy address information that the visitors will need to or want to know?
- Can the visitors easily find the key information points?
- Is the copy written in an interpretive manner (provoke, relate, and reveal information)?
- Is the copy written using active, colorful language?

- Does the copy get to the point?
- Does the copy use color text appropriately?
- Is the copy written in a simple, non-technical language? As a note, I write most of my exhibit and publication copy at a 5th grade (about 10-12-year-old) vocabulary level.
- If technical terms are used, are they illustrated or defined?
- Are larger/bolder paragraph or topic headers used to help the reader find key points?
- Does the copy have white space around it?
- Is it written in an editorial or speaking style?
- Does it leave the reader asking for more?
- Does it properly prepare the potential visitor for the promised experiences (are there restrooms, children's play areas, food services, etc.)?

Photos and graphics

As you begin to draft out your brochure (or critique an existing one), it is important to remember that visitors remember: 10% of what they hear; 30% of what they read; 50% of what they see; 90% of what they do.

It is said that a picture is worth a thousand words. The distressing point is that, if you don't pre-test the pictures you use in your brochures, it can be the *wrong* 1000 words!

A graphic assessment should consider the size of photos or graphics used. One really good, large photo is better than lots of small ones (see Fig. 13). Of the three photos on this cover,

Figure 13: The Wild River Adventures brochure cover illustrates several important marketing points:
- The target audience.
- Good/large action photo.
- Good use of top third space.
- Experiential marketing.

which one(s) do you think will get the target markets (visitors) attention? Which photo defines the market group that this attraction is trying to connect with?

- Photo composition – some important things to consider, many of which we have already illustrated include: Who is in the photo (market groups)? What are the people in the photo doing? (Hope they are having fun in a safe and stewardship-like manner.)

Figure 14

- How do non-visitor composition photos help you accomplish your objectives (why do you have photos with no people in them?

Do we always need to have people in the brochure pictures? There are times when no people in the photos might work. Particularly when you are trying to keep control over the numbers of visitors, or what you are marketing is the getting away from people experience. This approach is attractive

to very specific market groups. Can you name some market groups that this brochure style would appeal to as in the brochure examples in Fig. 14?

- Will you need color photos, or will black and white do?
- Will the photos you selected date you if they are not updated regularly?
- Do the photos clearly illustrate the strengths of the site or facility?
- Do the photos clearly identify the site or facility?

The photo selection self-test

Here is a little exercise you can do with an existing brochure. Cut out all of the photographs out of the brochure, lay them out on a desktop, and mix them up. Then ask staff members (or visitors) to see if they can tell you where the photos were taken (or are they photos that could come from anywhere, like a general lake photo, or fall color photo)?

Graphic assessments: sometimes a graphic will work better than a photo, and can give a better interpretation of the site.

Two graphic examples (Fig. 15) illustrate several points about the use of graphics. For the publication on the left (the Hermitage) which I have visited, the use of the graphic is OK, but the use of a good photo of the site would have been more powerful, and cost the same to print. In the brochure on the right, the use of graphics here can illustrate the complexity of the site (so many things to do), and note the market group identification in the graphic as well, and is a good example of use of graphics instead of photos.

Figure 15

More things to consider when using graphics:

- Do the support graphics clearly illustrate the theme, story or concepts?
- Are graphics simple and easy to understand?
- Is the use of a graphic here better than the use of a photograph?
- What size graphics should be used (look at objectives)?
- Is the graphic visual information market appropriate (will the user understand and correctly interpret what they are seeing)?

General leaflet/brochure layout assessment: putting it all together

___ Does the publication have attraction power and holding power?

___ Is the layout clean, simple, but yet powerful?

___ Is it clear as to the intent of the publication?

___ Can the user easily find needed information?

___ Have the *best* photos or graphics been selected (and pre-tested)?

___ Do the photos clearly illustrate the strengths of the site or attraction?

___ Do the photos clearly illustrate the intended market group(s) you want to attract?

___ Will the user be inspired and motivated to visit the site or attraction?

___ Can the user get the message mostly through visuals without having to read to much copy?

___ Does the layout support the theme and objectives of the brochure?

___ Has the draft layout been pre-tested to see if visitors like it as much as the person who designed it?

___ Is there white space to give the user visual breathing space?

___ Has the best type size and font, best paper size, color, texture, and weight been considered?

___ Has the right design been used for the intended distribution and presentation method?

___ What shows on the top third of your brochure?

Psychology of the intended tourist/visitor

Considering how visitors learn, remember and relate to your intended message:

- Have you given the potential visitor a reason to pick the brochure up?
- Can I clearly identify the target market group(s) your site is intended for? (Is your site or attraction for me?)
- Can I list three benefits I (my family) will gain by visiting the attraction if this is a marketing publication (three reasons I should visit you)?
- Are there photos with people in them that I can relate to?
- Do the photos illustrate the benefits I will gain by visiting the site/attraction?
- Are there clear directions as to how to find the site?
- Is there a usable map with landmarks I can look for (most visitors can't read typical road maps)?
- Have you given me an overview of customer services available?
- I don't like to read – is the text short, provocative, interesting?
- I can't read text printed over graphics! You try it!
- I can't read text that is too small and don't like to look at little photos.
- Is there a creative design to get my attention?
- In general, have you taken the risk out of the visit to your site or facility (I feel certain that I will get my money and time's worth from visiting you)?

Summary

In general, there are no right answers to creating successful brochures. There are lots of right answers. The test is which ones will work best in helping you accomplish your specific objectives for your unique target audiences, and which designs actually get visitors to show up.

This chapter is not everything, but enough to get you started in looking at your publications and helping to increase your chances of a successful brochure marketing strategy. And don't forget to pre-test any designs!

EVALUATION

31

Sample Visitor Center
Evaluation Strategy

Purpose

Quite often visitors to COE[1] projects and visitor centers do not come in direct contact with COE staff. It becomes the role of self-guiding interpretive services and media, such as COE visitor centers, to help visitors understand:

The Corps Mission

- How the Corps project site benefits the region, community, people, and the environment.
- Any special stories, projects or programs currently in place at any particular Corps project, such as archaeology programs, wildlife or fisheries management programs, etc.
- How to safely and responsibly use the Corps resources (water safety, etc.).

It is the role of this evaluation package to serve as a tool to assist project managers or staff in assessing the effectiveness of visitor center exhibits in effectively communicating with visitors about the project's mission, stories and benefits so that, if needed, exhibits can be modified or replaced over time to more effectively connect with visitors.

Interpretive vs informational exhibits

In general we know from various research studies that interpretive exhibits are more effective in communicating with visitors that informational exhibits. So what makes an exhibit interpretive and what is interpretation?

The Corps of Engineers defines interpretation as a:

Communication and education process provided to internal and external audiences, which support the accomplishment of Corps missions, tell the Corps story, and reveal the meanings of, and relationships between natural, cultural, and created environments and their features.

Interpretive exhibits are planned in a whole different way than informational exhibits in that interpretive exhibits must translate the exhibit information from the language of the expert into the language of the visitor. So interpretive exhibits translate concepts. Interpretive exhibits are also planned to be outcome-based or product-based. That means that every exhibit should be designed to accomplish specific objectives (learning objectives, emotional objectives and behavioral objectives). The true test of an exhibit being good is then based on how well the exhibit accomplishes these stated objectives.

Theme-based visitor center exhibits

In evaluating visitor centers and their exhibits, another key area for review is the clarity in which the interpretive THEME of the project or visitor center is presented. An interpretive theme is the one main idea or concept that you feel it is important for the visitors to remember, feel or do as a result of the visitor center exhibit experience. Ideally COE visitor centers should have one clearly stated theme which all of the exhibits in the visitor center help illustrate. For example: The XYZ project manages water and wildlife resources to benefit the region and people in three key ways.

This is an example of an interpretive theme for a visitor center exhibit room. Based on this theme, exhibits would be planned to illustrate just how the XYZ project manages water and wildlife resources to benefit the region and people – what are the three ways?

Interpretive themes for COE visitors centers are critical in helping make sure visitors receive a clear understanding of the role of COE project sites.

Outcome-based exhibits

COE visitor center exhibits should be planned and designed to produce a product or outcome. For example, if a project spends $10,000.00 on exhibits for the VC, the question is what are you getting in return for your $10,000.00 investment? With this visitor center exhibit planning approach, COE visitor centers can use
more cost-efficient and cost-effective exhibits. Every COE visitor center exhibit should then be objective based, as mentioned earlier. For COE visitor center exhibits three types of objectives are recommended:

Learning Objectives: (Example) As a result of interacting with the exhibits the majority of visitors will be able to list three ways this project benefits people and the environment.

Emotional Objectives: (Example) After viewing the exhibits, the majority of local residents will have an increased sense of community pride in having a COE project so close by them.

Behavioral Objectives: (Example) As a result of interacting with the visitor center exhibits all visitors who boat will wear

their PFD's.

What makes an exhibit interpretive?

Another important area for evaluation is the interpretiveness of exhibits. In general the basic principles of interpretation are that the message or exhibit presentation should:

Provoke the attention, interest or curiosity in the visitor to want to know. This is done in exhibits with provocative exhibit headers such as *This Plant Could Save Your Life* or by using large or provocative graphics or photos.

Relate to the everyday live of the visitor. We need to give visitors a visual understanding of terms and concepts using analogies, metaphors and similes. An example might be: If a section of the water channel were diverted through your living room, it would only stretch from the floor to the ceiling. That's enough depth for these gigantic ships to pass through this waterway.

Reveal the main concept or point through some creative or unusual viewpoint or style. Give the answer last! For example Did you know that this dam churns out nearly 1.2 million kilowatts per year – enough electricity to light ___ cities for ___ months!

So one important component in evaluation of COE visitor center exhibits is looking at just how well these interpretive principles are used.

Visitor center exhibit load

The concept of exhibit load is a simple one. Every time a visitor views or interacts with an exhibit they use up energy and enthusiasm. The more exhibits visitors see and interact

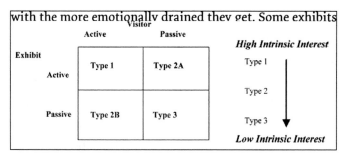

Figure 1: Exhibit interest

have a high load – that means they require the visitors to think and concentrate more – using up more energy. Other exhibits are low load requiring less effort from the visitors to interact with them. There are four basic kinds of exhibits, each having a different load factor. We can use this to analyze existing exhibits (or plan for new ones) to help explain such things as:

- Visitor flow patterns in visitor centers – visitor are attracted to high load exhibits.
- Staying power visitors may have at particular exhibits (average viewing time is 15 seconds).
- Why some exhibits are simple passed by and not looked at.
- Why some visitor centers may be considered boring by visitors.

Exhibit interest (Fig. 1)

Type 1 exhibits are where the exhibits does something and the visitor does something, an interactive exhibit such as a

computer exhibit.

Type 2 exhibits. These are exhibits where the visitor does something put the exhibit is inert, or where the exhibit does something but the visitor doesn't. Aquariums are good examples of type 2a exhibits (the exhibit is active but the visitor just watches). Other examples of 2a exhibits are video programs, watching model locks work, or watching a boat go through a lock.

Type 3 exhibits. These are exhibits where the exhibit does nothing and the visitor does nothing. Flat work graphics or materials in cases. These exhibits usually have the lowest interest for visitors.

What does exhibit load analysis tell us?

By looking at the exhibit load for the total visitor center and for individual exhibits, we might be able to overcome boring exhibits by doing some exhibit rehab work to make the type three exhibits more interactive. In general you should have a mix of exhibit types:

- Approximately 20% type 1 exhibits.
- Approximately 60% type 2 exhibits.
- Approximately 20% type 3 exhibits.

This balance of exhibit load allows for visitors to have fun with challenging exhibits, and use the type 3 exhibits as mental resting points.

In general, visitors remember: 10% of what they hear; 30% of what they read; 50% of what the see; 90% of what they do.

Based on this, it is important for COE visitor center exhibit to provide a mix of all of these components, with the visual and hands-on components of exhibit design being key to exhibit concept retention by visitors.

Design considerations for interpretive exhibits: general rules
- Label copy should use bold, provocative headers to draw the visitor's attention. Copy should be about 50 words long, with not more than 100 words per exhibit segment. (two 50 word paragraphs).
- Label copy text should be no less than 30-point size.
- Most visitors only spend about 15 seconds per exhibit. If you can't get the main point across in 15 seconds, you probably won't get it across at all.
- Any photograph should have a caption with it, otherwise visitors will probably make-up their own and it will be incorrect.
- Ask yourself – why would a visitor want to know this information? If you can't come up with answers you will probably have a walk-by exhibit.
- Ask yourself – how do you want the visitors to *use* the information the exhibit is providing? If the visitors can't use the information then why are you giving it to them?

Having successful interpretive exhibits
To have truly successful visitor center exhibits requires a combination of factors. The exhibits in a visitor center must

work together to illustrate a common theme and objectives for the *total* visitor center experience. The exhibits should follow good design considerations for visual graphics and length of text. Exhibits need to be designed based on Tilden's Interpretive Principles. And the exhibits in the visitor center need to be paced considering the exhibit load concept of exhibit attraction power. All of these factors, when mixed together properly, can produce outstanding and cost-effective interpretive exhibits for any COE visitor center.

It is the goal of this document and evaluation strategy to help you learn just how effective your exhibits are in helping you accomplish your project's mission and in communicating your unique story to your visitors. Likewise, this can also serve as a tool in helping to learn which of your current visitor center exhibits are just fine, which need a little re-hab work, and which exhibits need to be replaced.

Visitor/Interpretive Center Assumptive Evaluation Form
In conducting scientifically valid evaluations for visitor centers or interpretive centers for any agency or organization, the evaluation team must first have an understanding of the specific objectives, outcomes, or managerial realities of that facility (available budget, time constraints, etc.). In addition it would be required to know the target market groups the center was designed for as well (local repeat visitors, one-time tourists, school groups, bus tour groups, etc.) to see if the facility design, services and exhibits are indeed effective in serving and communicating with those target market groups. If this information is not available then a formal evaluation against stated outcomes cannot be done. The next option is called an *assumptive evaluation* or auditing by an expert.

The assumptive evaluation is conducted against evaluation criteria where the expert or team of experts, not knowing what the original planning and design objectives were, assume what the intent of the design was, and do an evaluation against these assumptions. In addition, the team would critique the facility and exhibits against a general criteria of professionally accepted standards, such as for interpretive exhibit design or handicapped accessibility.

While not scientifically valid, the assumptive evaluation does have benefits for the agency managing the visitor or interpretive center being critiqued. Ideally, the conclusions that the team assumes were the main interpretive theme, messages or concepts are indeed very close or right on to what the visitor or interpretive center intended the main take-

away messages to be. That would illustrate that the Center is indeed communicating its mission and story effectively to visitors. However, if the main interpretive theme, concepts or messages the evaluation team assumes were the main focus or outcome were *not* what the visitor or interpretive centers main exportable theme or concepts were – then the center is *not* effectively communicating its mission and stories to visitors. If that is the case, then a more formal scientifically valid evaluation would be needed to isolate the problems and recommend changes to make the center more effective in communicating with visitors for that particular facility.

Visitor Center Assessment Form

Introduction: This Visitor Center Assessment form is used for conducting Assumptive Evaluations – where evaluating against stated objectives or outcomes is not possible. It is designed to critique the Visitor Center against a list of generally accepted professional planning, design, and interpretive communication criteria and standards. The completed evaluation can serve as a tool to both support or validate visitor center and exhibit success or strong points, or note areas in visitor center and exhibit design that could use improvement. Note that the results are subjective and based on the background and professional training of the evaluator or evaluation team.

Instructions: Each evaluator should answer each question in the survey based on their personal understanding of professional standards for the subject, site or facility being critiqued. Space is provided (or use the back of this form) for additional written comments you might have about a particular question.

Facility Name: _____

Location: _____

Agency: _____

Pre-visit and facility exterior assessment
Was the highway signage providing directions to this site:
a. Poor b. Adequate c. Very Good

What improvements to the visitor directional signage would you recommend?

What were your first impressions upon arriving at the facility?
- Looks well designed, landscaped and inviting.
- Looks like an average visitor center.
- Looks like an average government building.
- Looks like an office – hard to tell there was a visitor center in there.
- Other _____

On a scale of 1 to 5, how would you rate your first impression of this facility before going into it?

Poor Good or Average Looks Great/Inviting

1 ------------2-------------3-------------4-------------5

How would you rate the facility grounds and landscaping:
- Poor – looks in kept.
- Average – grass is cut, looks OK.
- Very Good – good or appropriate landscaping, well maintained.
- Other: _____

How would you rate the building appearance:
- In poor shape in need of obvious repair.
- In average shape, some repair work needed.
- In good shape, looks well maintained.
- Other: _____

Agency identification – is it clear as to which agency manages this facility via logos or other outside identification:
Yes_____ No_____ Other_____

Is there an outdoor orientation board, panel or kiosk that visitor can use prior to entering the facility that tells them about the site, facility, resource locations, or other orientation information:
Yes_____ No_____

Are there any outdoor interpretive panels or experiences that visitors might encounter before they enter the visitor center:
Yes_____ No _____

If yes, do these interpretive materials help introduce the main theme or mission of this particular facility?

Is there an obvious handicap accessibility route from the parking area into the visitor center? Yes_____ No _____

In general, given all of the above considerations, how would you rate the your total exterior impression of this facility:
Poor-----Needs Work-----Average-----Good/Excellent
1 ------------2------------3------------4------------5

Visitor Center Internal Assessment

Upon first entering this facility, what were your general first impressions (did you like it, not like it, didn't know where to go, etc.)

What do you think that the visitor's first impressions or feelings about this facility might be?

Was there a receptionist or greeter when you entered?
Yes_____ No_____
If yes, how was your welcome?

When you entered, was it clear as to where restrooms, exhibit rooms, etc. were located? Yes____ No_____
- What is the mix of interpretive programs or services available (circle all that apply)
- Exhibit room
- Outdoor viewing area
- Theater production/AV show
- Live interpretive programs
- Other_____

Was it clear at the beginning what the main objectives or mission of this center was?

Yes_____ No _____

The exhibit room

When you first entered the exhibit room, was there an orientation exhibit that told you the main interpretive theme or purpose for this exhibit area and visitor center?

Yes_____ No_____

What do you think the main interpretive theme or message for this visitor center is?

How would you rate your first impression of the exhibit room:
- Visually poor, didn't look very inviting or stimulating.
- Exhibits looked OK, not a lot of sparkle or draw.
- Looks like typical exhibit room – average
- Looks above average – inviting, visually well done.
- Excellent – looks like fun, visually draws me in.
- Other: _____

Does the exhibit room appear to be handicap accessible (room for wheelchairs between exhibit elements, etc.

Yes_____ Somewhat_____ No_____

Are the exhibits visually accessible to visitors in a wheelchair (proper sight lines or access to interactive exhibit elements? Yes_____ Somewhat_____ No_____

Are there hands-on or tactile exhibits appropriate for visually impaired or blind visitors? Yes_____ Somewhat_____ No_____

Are there any exhibit materials, exhibit label copy, or other educational materials that relate to the exhibits that are available in braille? Yes_____ No _____

What is the age of the current exhibits (installed in....) _____

What is the current condition of the exhibits in general:
- In poor shape, old, and in need of replacement.
- In fair shape, will need some rehab work to update some of the exhibits ASAP.
- In good condition, need some update work in next year or two?
- In excellent condition.

Answer the following questions after you have had a chance to look at the exhibits.
In general, did you feel that the exhibits successfully communicated to visitors the main interpretive theme of the visitor center? Yes_____ Somewhat_____No_____

In general, did you feel that the majority of the exhibits effectively illustrated the main mission, story or theme of this visitor center? Yes_____ Somewhat_____No_____
(*feel free to comment on the back of this page*).

In general, did you feel that the text or content level presentation of the exhibits were:
- Written to simply or needed more information
- Written at the correct content level (5th grade vocabulary).
- Written at to technical off a content level
- Other: _____

In general, did you feel that the point size of the main label text copy:
- Was two small and hard to read.
- Was OK or about average
- Met professional museum standards of about 30 point size or larger.

In general, how would you rate the attraction power of the exhibits (their ability to draw you to them and hold your attention).
- Poor – most did not look interesting.
- About average – about half looked interesting.
- Excellent – most exhibits looked inviting

Of all of the exhibits you looked at in this center, how many exhibits out of the total did you look at and read *all the exhibit label copy?*

- Only a few of the exhibits.
- About half the exhibits.
- Most of the exhibits.

In general, what do you think the *average time* you spent interacting with (reading the label copy, doing interactive activities) the exhibits in this exhibit room or gallery?

- Under 15 seconds per exhibit.
- Between 15 seconds and 1 minute per exhibit.
- Over 1 minute per exhibit.

In general did the exhibits look well maintained:
Yes_____ Somewhat_____No_____

Were any interactive exhibits out of order? Yes____ No____
If yes, about how many? _____

Media mix and exhibit load
Exhibits are rated by their load factors, that being the amount of energy (cognitive, physical or both) that the exhibits requires a visitor to expend in order to interact with the exhibit. There are basically three kinds of exhibits:

- Type 1 – Interactive exhibits: visitor is active, exhibit is active.
- Type 2 – Exhibit where either the visitor is active

(touch table) or the exhibit is active (watching a video).
- Type 3 – Visitor does nothing, exhibit does nothing (graphic flatwork, display cases).

The type 1 exhibit has the highest load, the type 3 the lowest load. Visitors have the highest intrinsic interest in Type 1 exhibits and the lowest interest in Type 3 exhibits. In general we like visitor center exhibits to have a exhibit load mix of:
- Type 1 exhibits 20%
- Type 2 exhibits 60%
- Type 3 exhibits 20%

Based on the above ideal load mix, what do you think in the exhibit load mix for this visitor center exhibit room?
Type1 _____ Type 2 _____ Type 3 _____

Interpretive exhibits are different from purely informational exhibits in that interpretive exhibits must translate information into terms and analogies that everyday people can relate to and understand. The following critique questions will focus on the perceived interpretive level of exhibit design and presentation.

In general, how well do you think that the exhibits used the interpretive design concept of provocation to get your attention?
- Not at all
- Somewhat
- Very well

In general, how well do you think that the exhibits related to the everyday lives of visitors (via analogies, metaphors, or other ways for the visitor to better understand technical concepts)?

- Not at all
- Somewhat
- Very well

In general, how well do you think that the exhibits revealed their stories and key concepts to visitors (using surprise endings or other design/text strategies to have the visitors guess what the answer might be before revealing the answer to them)?

- Not at all
- Somewhat
- Very well

In general, and based on Tilden's Interpretive Principles, how would you rate the exhibits for their interpretive communication use:

- Very poor – mostly information, not interpretation.
- Somewhat interpretive – use of interpretive principles in about half the exhibits.
- Very interpretive – use of all interpretive principles in most exhibits.

An important part of the total exhibit experience is what you remember most by the time the exhibit room visit is over.

What do you think were the three most important concepts or ideas that you personally gained from this visitor center exhibit experience:

Do you think that these were the three main concepts that the visitor center managers/agency wanted you to leave the visitor center knowing or feeling?

Yes_____ No_____ Not sure_____

On a scale of 1 to 5 (with 5 being the highest rating you can give a visitor center or interpretive center in being able to *effectively present and interpret its mission and story to visitors so that visitors will remember* the main theme or messages after leaving the center) how well do you think this center did:

Poor-------Average-------Above Average-------Far above average

1--------------2------------------3----------------4--------------5

General evaluation discussion

What recommendations for visitor center improvements (exterior and interior) can you suggest (if needed).

What barriers or issues could possibly hinder putting the recommended improvements in place? (in consultation with site staff)

What would you consider to be the key or priority recommendations that should be done first (if any)? (in consultation with site staff).

In general (from center staff), what is your annual exhibit maintenance and upkeep budget. Do you think that it is satisfactory?

In general, which exhibits cause you the most problems (maintenance, etc.) and why?

Individual Interpretive Exhibit Design Critique

Instructions: This evaluation form should be copied, with one form set being completed for *each individual exhibit* in your exhibit room.

Exhibit Name or Subject: _____
Does this exhibit have content and design objectives in writing? YES NO
If yes, use a copy of the original objectives as part of the exhibit critique.

This exhibit is a:
Type 1____ Type 2a_____ Type 2b_____ Type 3_____

From the exhibit design, are the *intended* objectives of this exhibit clear?

Learning Objective:

Behavioral Objective:

Emotional Objective:

Does the exhibit have a clear theme? YES NO
If yes, what is it?

Does the exhibit subject or presentation provide an example that clearly illustrates one of the total visitor centers sub-themes or illustrate the main interpretive theme? YES NO

Does the exhibit get its main point across in 15 seconds or less? YES NO

Does the exhibit use interpretive techniques in its design and copy?
What is the *provoke* for this exhibit?

--

What is the *relate* used here?

--

What is the reveal?

--

On a scale of 1 to 5, how would you rate the use of provocation in this exhibit:
No use----------Somewhat----------Very provocative
1-------------2-------------3-------------4-------------5

On a scale of 1 to 5, how would you rate the use of *Relating to the everyday live of the visitor* in this exhibit?
No use--------------Some use--------------Good use
1-------------2-------------3-------------4-------------5

On a scale of 1 to 5, how would you rate the use of the concept of *reveal* in this exhibit?

None ------------------Some ------------------Very good

1--------------2--------------3--------------4--------------5

What is the required viewing/reading time for this exhibit?

_____ minutes

What is the actual viewing time for this exhibit?

_____ minutes.

When you look at this exhibit subject, topic or content, answer the question: Why would a visitor want to know this? If you find it difficult to answer this question it may explain why visitors might ignore this exhibit.

When looking at this exhibit, answer the question: How do you want the visitor to *use* the information this exhibit is giving them? If visitors can't use the information, then why are you giving it to them?

How would you rate the label copy for this exhibit?

Boring--------Somewhat well written--------Very well written

1--------------2--------------3--------------4--------------5

How would you rate the selection of graphics or photos for this exhibit?

Boring--------Somewhat interesting--------Very interesting

1--------------2---------------3---------------4--------------5

How would you rate the amount of label copy for this exhibit?

To much to read--------Somewhat OK--------Just right

1--------------2---------------3---------------4--------------5

How would you rate the kinds of artifacts used in this exhibit or display?

Uninteresting------Somewhat interesting------Very interesting

1--------------2---------------3---------------4--------------5

Given your responses to the previous questions, do you feel that this exhibit is:

- Just fine, works to illustrate our theme and accomplishes its objectives. Keep it.
- Is somewhat OK, but needs some re-hab design to make it more effective.
- Does not contribute to accomplishing any of the project's missions or visitor center objectives and should be replaced with more effective and focused interpretive exhibits.

If your answer was #2, needs some re-hab work to make it more effective, what are some ideas you have as to how that may happen. Any ideas or suggestions?

Notes

1. This material was originally created for the US Army Corps of Engineers (COE)

32

Exhibit Evaluation
For Children's Exhibits:
The Kirby Science Center Experience

Why Ask?

Evaluation has long been a part of any interpretive planning strategy, especially for interpretive center or museum exhibits. When you consider the costs of exhibits to agencies (estimated at $300 per square foot of exhibit floor space) you would think that before the exhibits were delivered the agency would want to make sure they worked, i.e. accomplished the objectives they were designed for. Unfortunately this evaluation process rarely happens and many exhibits quietly fail to make any contact with visitors.

I was a part of the Derse Exhibits team to plan, design, build and evaluate exhibits for the Kirby Science Center, in Sioux Falls, South Dakota. They had three empty floors and wanted top quality science exhibits to fill the building – a $3,000,000.00 project. Part of the total project the client wanted was a thorough evaluation of exhibits to make sure that each exhibit accomplished its specific interpretive objectives. This chapter will summarize what and how the evaluation took place and what I and the team learned from this wrenching experience called evaluation.

What were the exhibits supposed to do?

Before you can evaluate anything you have to first know what it was supposed to accomplish. Part of the total exhibit plan was an Interpretive Exhibit plan. This consisted of each individual exhibit having – in writing – a specific concept the exhibit was to present, and specific learning, behavioral and emotional objectives each exhibit was held accountable to accomplish.

We would later evaluate the mock-up exhibits against those stated objectives.

The evaluation strategy

For this evaluation strategy I developed several different evaluation methods to be used for the total evaluation. The evaluation would take approximately four weeks to do. We set up draft/mock-up exhibits in the warehouse of Derse Exhibits – evaluating approximately 15 exhibits each week, representing six different science subject areas. We then arranged with local schools for teachers to bring in their classes to test the exhibits for us. We would test each set of 15 exhibits over the course of one week. The evaluation strategies included:

A *written pre-test and post-test*: We brought in school busses of children from different schools to be our audience for the evaluation. Before being allowed to use the exhibits each group took a short written multiple choice and true/false pre-test relating to each exhibits objectives. After the pre-test the children could then go and use the exhibits. After spending about 45 minutes with the exhibits they came back for a written post-test. We wanted to see if there was any change in what they knew about the tested science concepts from before seeing and using the exhibits – and then after they interacted with the exhibits.

Observational studies: This part of the evaluation used a trained observer stationed at each exhibit to simply watch/ record what the children did or didn't do. This told us a lot about things like instructions, graphic placements, and

subjects that children did and didn't have any interest in.

The quick fix – and fix – and fix again: Essentially our plan was to have two groups of children test the exhibits on Monday of each of the four weeks. We would then analyze the test results and our observational results – make any changes to the exhibits on Tuesday – bring in two new groups of students on Wednesday – make any more corrections on Thursday – do one final test on Friday – make any final adjustments, and then ship out the completed exhibits from that weeks testing on to the Science Center over the weekend. We would then repeat the evaluation process the next week for 15 different exhibits.

What we found out: Oh the pain!

What did we learn from this experience? We learned that if we had not done the testing the great majority of the exhibits we adults planned would have been failures! Virtually *every* exhibit we tested had to be fixed in some way. Here are a few examples of some of the things we observed.

For example, with an exhibit on magnetism you were directed to move the magnet on the chain *under* the objects, the magnetic items would then move. Not one child followed these directions. They only used the magnet from above! They wanted to see the magnet on the chain interact directly with the item in the exhibit. We fixed this by changing the directions and raising items in each container so magnetic objects would react with the magnet held from above. We found that children found any written directions to be invisible. In 98% of the cases the children did not look at or read any directions unless an

adult suggested they do so. If they had to read complex directions to do the activity – they usually left the activity.

We also were able to test the construction of the exhibits themselves, and some of the exhibit tools. For example, our indestructible microscopes didn't last a week!

What we learned

This month-long evaluation process taught us all a lot, the most important of which was that if we hadn't done the evaluation we would have built exhibits using adult ideas of how children learn that children would *not* have learned from. Some key points.

From the pre-post tests, we found that there were some subjects students already had good concept level understanding of – pre-tested at a 80% correct response or higher on the written test; and some areas they had a very poor understanding of – with correct responses on the pre-test of 50% or less. We did find that when comparing the pre-test and post-test results, there were often increases in correct answers on the post-tests, depending of the individual exhibits. So the exhibits were generally working – but the initial post-test improvements were generally very weak, may be only 5-15% improvements on post-tests at the start of the week (Monday testing). But by Friday, after the exhibits had gone through many changes in design, instructions presentation, and concept presentation, we were at an average of 80% comprehension or better on post-testing for most exhibits. By doing this formative evaluation through out the week of

testing, we were ending up with very good to excellent exhibits as far as having their educational objectives accomplished at a 70% level or higher (our goal).

We found that *every* exhibit we evaluated over the four -week period (about 60 exhibits) had to have some improvements. Some exhibits just needed a little fix – such as the addition of a label that said *Push the button* (otherwise the button to start the activity would not be pushed), to some exhibits needing a major re-design.

We found that children did not even look at, let alone read any written instructions. But we did have success in redesigning instructions in cartoon or comic book formats – more visual presentation instructions. The instructions themselves had to look fun or interesting. For many of these exhibits to be used most efficiently would require a docent, science educator or teacher to help facilitate and direct the learning activity. But the exhibits did work effectively on their own after evaluation driven re-designs. When our researchers facilitated the learning – explaining directions, etc. the exhibits worked wonderfully.

The design team and the client all learned that the *only* way you will know for sure if you have a successful exhibit – not just a pretty exhibit – is to evaluate it with your intended target market group. The visitors will tell you if your exhibit is successful in communicating with them or not – if you ask them!

Summary
This chapter only begins to touch on some of the many complex educational issues and design challenges we encountered by doing this evaluation. My goal was to provide an introduction as to why evaluate, and how the process helped us to finally design and build exhibits that were really educationally successful. We believe that based on all that we learned about exhibit users for this museum, that evaluation for any exhibit project is not an option but a requirement for true exhibit success.

References

Veverka, John A. 1998. *Kirby Science Center Exhibit Evaluation Report*. Unpublished report for the Kirby Science Center, Sioux Falls, South Dakota.

Veverka, John A. 1999. *Where is the Interpretation in Interpretive Exhibits?* Unpublished paper.

About The Author

John Veverka received his B.S.(1976) and M.S.(1978) degrees majoring in Interpretive Services from The Ohio State University (OSU), with additional minors in marketing, motivational psychology, and advertising. During this time at OSU, he developed and taught a course on Interpretive Master Planning, was also on the staff of the Ohio State University Museum of Zoology (academic years) and spent five summers as an Interpretive Naturalist with Ohio State Parks.

After graduating with his M.S. degree, John was recruited by Alberta Provincial Parks in Canada (1978-1980) where he helped develop interpretive plans for two World Heritage Sites (Head-Smashed-In Buffalo Jump and Dinosaur Provincial Park). In 1981 he returned to Michigan to teach introductory and advanced interpretation courses at Michigan State University, where he was also enrolled in the Ph.D. program (1981-1985).

Besides interpretation, John studied recreational learning theory, consumer behavior, recreational marketing and survey research strategies. His current work as a consultant in interpretive planning, training and heritage tourism, spans 34 years and takes him all over the world, working on projects in Korea, Canada, Spain, Mexico, England, Scotland, Wales, Greece, Malta and throughout the United States. He lectures widely on Heritage Interpretation and Interpretation Planning, and serves as a consultant to many different agencies and organizations worldwide.

John is a:

- Certified Interpretive Planner
- Certified Interpretive Trainer

- Certified Professional Heritage Interpreter (Canada)
- Instructor in Interpretation at the Snowdonia National Park Training Center, Wales
- Contributing Author in the book *The Language of Live Interpretation*, Museum of Civilization, Canada
- Associate Editor – *The Journal of Interpretation*

For over 30 years John's firm, John Veverka & Associates, has provided a variety of international interpretive consulting services for parks, museums, zoos, historic sites and industrial clients including:

- Interpretive Master Planning
- Interpretive Training Courses and Workshops
- Regional Interpretive Systems Planning
- Evaluation of Interpretive Services
- Interpretive Exhibit Planning
- Interpretive Facilities Feasibility Analysis
- Interpretive Trail and Tour Planning
- Heritage Tourism Analysis and Development
- Industrial Site Interpretation
- Interpretive Writing and Script Development

www.heritageinterp.com

John Veverka presenting a session on interpretive planning at the Baekdudaegan Forest Sanctuary and Discovery Center Conference, Seoul, S. Korea, 2010.

Index